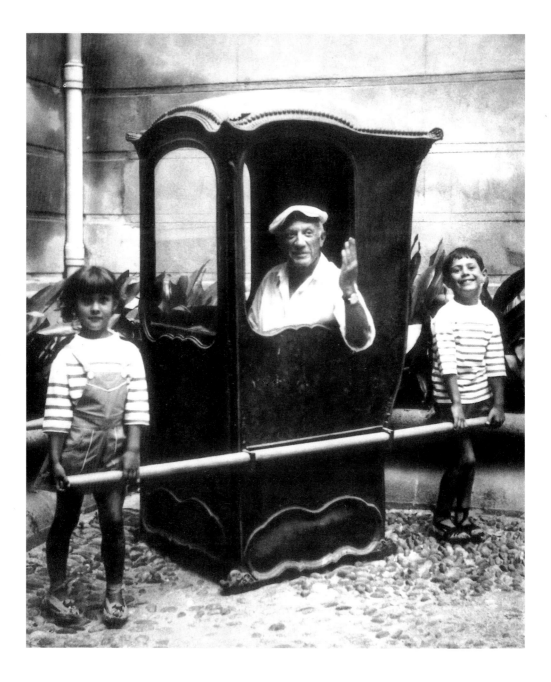

Werner Spies

Picasso's World of Children

Prestel

© Prestel-Verlag, Munich · New York 1994
© of all works by PABLO PICASSO
VG Bild-Kunst, Bonn 1994

Translation from the German by John William Gabriel

Cover illustrations:
Front: *Paolo as Harlequin* (detail), 1924 (see p. 57)
Back: *Child with Dove* (detail), 1901 (see p. 13)
Frontispiece:
Picasso in a sedan chair, with Paloma and Claude, ca. 1955
(Musée Picasso, Paris)

Distributed in continental Europe by Prestel-Verlag
Verlegerdienst München GmbH & Co. KG,
Gutenbergstraße 1, 82205 Gilching, Germany
Tel. (8105) 388117; Fax (8105) 388100

Distributed in the USA and Canada on behalf of Prestel
by te Neues Publishing Company,
16 West 22nd Street, New York, NY 10010, USA
Tel. (212) 6279090; Fax (212) 6279511

Distributed in Japan on behalf of Prestel
by YOHAN Western Publications Distribution Agency,
14-9 Okubo 3-chome, Shinjuku-ku, Tokyo 169, Japan
Tel. (3) 32080181; Fax (3) 32090288

Distributed in the United Kingdom, Ireland,
and all remaining countries on behalf of Prestel by
Thames & Hudson Limited,
30-34 Bloomsbury Street, London WC 1 B 3 QP, England
Tel. (71) 6365488; Fax (71) 6361695

Cover design by F. Lüdtke, A. Graschberger, A. Ehmke, Munich
Lithography by Fotolito Longo, Frangart
Typesetting by Reinhard Amann, Aichstetten
Typeface: Bauer-Bodoni
Printed and bound by Passavia Druckerei GmbH, Passau

Printed in Germany

ISBN 3-7913-1375-4

Contents

8 Islands in the Oeuvre

10 Childhood: A Strategy of Beginning

19 The Early Years and the Blue Period

21 Joyless Children

26 The Child as Symbol

27 "There Was Never Any More Inception
 than There Is Now"

39 The Disguises of the Rose Period

41 Primitivism and Childhood

43 Cubism: The Search for a World without Childhood

45 The Motif Returns

50 Neoclassicism and Stylistic Pluralism

62 The Courtly Portrait of His Firstborn

64 Private Life and Mythological Projections

65 The Dead Children:
 Guernica and *The Charnel House*

75 The Limits of Representation

90 "First Steps"

96 Objets Trouvés and Toys

108 Entering the Child's Perspective

111 Late Works

122 Notes

123 List of illustrations

For Sophie and Jérôme Seydoux

Acknowledgments Picasso's oeuvre is accompanied by many depictions of children. Oscillating between fragile happiness and helpless melancholy. these pictures convey something of the richness of life itself. with its endless variations of tone and mood.

There are many people to whom thanks are due. I owe a particular debt of gratitude to the following members of the artist's family: Catherine Hutin-Blay. Sydney and Claude Picasso. Paloma and Rafael Lopez Cambil. Marina Picasso. and Maya Widmaier-Picasso. I would also like to thank Anne Baldassari. Heinz Berggruen. Marie-Laure Bernadac. Laurence Berthon. Ernst Beyeler. Gilbert de Botton. Piero Crommelynck. Bernd Dütting. Ann Hindry. Jan Krugier. Carolyn Lanchner. Hélène Lassalle. Brigitte Léal. Paule Mazouet. Lionel Prejger. Gérard Régnier. Henning Ritter. Angela Rosengart. William Rubin. Hélène Seckel. Jeanne Sudour. and Armin Zweite.

W. S.

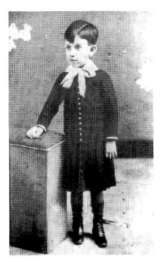

Pablo, aged four

In recent years a great number of exhibitions and publications have been devoted to Picasso's oeuvre. His late work has exercised a special fascination, recording as it does the uncensored and deeply harrowing confessions of a man who had become a legend in his own lifetime and fought to the last against aging and death. Everything he presents in these wild, unleashed paintings – heads merging in a voracious kiss, eyes filled with a fear of death, bodies joined in love's neverending battle – exudes a harsh, dissonant feeling that mirrors the mood of our times.

This book looks at a more harmonious side of the artist's work. Pictures of children are a more conventional and obviously pleasing subject which might be thought capable of reconciling even those who abhor the formal excesses of modern art with Picasso the great iconoclast. Certainly, many of these paintings and drawings are a pleasure to the eye and a joy to the heart. Some of them possess a tenderness and brilliance that place them fully on a par with the most highly regarded pictures of children in the history of art, whether by Raphael or Leonardo, Velázquez, Rubens or Goya. Yet when Picasso's treatment of the subject is seen in relation to his oeuvre as a whole, it turns out to be much more complex and far-reaching than is initially apparent. The idyllic, amiable quality that so immediately strikes the viewer draws much of its sustenance from a dialectical relationship to the drama and power of other facets of the artist's visual repertoire. In sum, Picasso's pictures of children have to be seen in the context of an often problematical oeuvre. Their role and function within his aesthetic require careful examination. The Picasso who confronts us in these images raises a number of questions, the answers to which shed a fresh light on his life's achievement. To Picasso the iconographer, children posed a problem more exacting and rife with contradictions than any other subject he dealt with.

Islands in the Oeuvre

As always when one attempts to isolate a particular motif or technique from the remainder of Picasso's vast oeuvre, one is initially discouraged by its sheer abundance. Although the subject was not one of his continuing preoccupations, the number of paintings and drawings that reflect his attitude to children runs to several hundred. Moreover, the works are extremely varied in character, and, one must add, they occur in tight-knit groups, like islands in the artist's oeuvre. Picasso only turned to the world of children at certain limited points in his career. However, children appear in every medium he employed, be it painting, drawing, sculpture or printmaking. A chronological presentation of his work on the theme is bound to emphasize the lack of unity in his approach, its diversity of mood, its moments of tenderness offset by sudden pangs of anxiety. The subgenres employed are equally varied, ranging from the individual portrait to the family picture, from mythological embellishments of the motif to conventional groupings.

Boy Scratching Himself 1896

By and large, it is helpful to distinguish between two broad categories of works: the "impersonal" pictures, using children as a general motif, and the portraits of Picasso's own children. As the oscillations in tone and mood in both categories illustrate, Picasso did not look upon the child, or childhood, as a given, fixed condition. In his prolific variations on the theme, he recapitulated certain iconographic models taken from the history of art, while at the same time continually searching for new approaches and formulations. Much of his work in the field betokens a conscious exploitation of the subject's conventional charms, yet even more of it transgresses accepted notions of family life and childhood security. All these various tendencies are played out against a universal backdrop of emotions ranging from touching gentleness to anger and intimations of mortality. Simulations of order and courtly ceremony alternate with suggestions of a chaotically antiauthoritarian laissez-faire.

Reviewing the material in its entirety, one can say that the appearance of children on Picasso's stage was determined by certain precisely definable circumstances. In Barcelona and during the early Paris years, narrative themes still occupied a comparatively important position in his work. It comes as no surprise that children – mostly little boys – play a key role in the group scenes,

which receive more emphasis at this point than in any later period. In every case, these pictures are studies relying on motifs, rather than individual portraits. The most striking examples of Picasso's use of the child as motif occur in the 1930s and 1940s, in particular the little girl who appears in a series of surreal, mythological scenes of the earlier decade. In *Guernica*, in a number of studies that accompanied this outcry against the horrors of war, and in *The Charnel House* (p. 88) of a few years later, her broken corpse symbolizes the ultimate extreme of terror.

After the motif came the portrait. In general, Picasso's depictions of individual children are bound up almost exclusively with his own biography. The few drawings and paintings he made of children outside his family were nearly all done while he himself was still childless. This applies to commissioned works like *The Soler Family* (p. 25), to his portrait of Allen Stein (1906), and to that of the art dealer Paul Rosenberg's wife with her daughter (1918). After 1920, however, over three-quarters of the paintings that touched on the subject of children were devoted to Picasso's own offspring – Paolo (born in 1921), Maya (1935), Claude (1947), and Paloma (1949). We rapidly sense that we are dealing here for the most part with confessions which hold an exceptional and intimate place within the artist's oeuvre. Only a very few of these pictures for the family album ever left his studio.

Granted, a more personal subject than one's own children is difficult to imagine. Yet in his renderings of the childhood world with which he was apparently so familiar, Picasso continually introduced a factor of detachment and incommensurability, describing a liturgy of strange, baffling gestures and behavior. Especially in the late 1940s and early 1950s, he was a fascinated observer of the animality of childish, precivilized existence. Perhaps this search for spontaneity partly explains why, after an initial flush of interest, the artist so rapidly turned away from the individual child, the biographies of his own children. His work yields a surprising insight: the children who appear in it are all very young. By the time they reached puberty, they had disappeared from his art. After Picasso had completed his family album, he did almost no further portraits of children.[2] In later years, their role was taken over, in virtually every case, by the putto.

Mademoiselle Rosenberg 1918

Childhood: A Strategy of Beginning

As these comments imply, what we are dealing with here is not a simple, one-dimensional subject. Its presence is attended by a number of different meanings. The revelations Picasso continually makes in his depictions of children raise issues of both an aesthetic and a personal nature. In what relationship do his works stand to those of his contemporaries? And to what extent do they contribute to a definition of the genre?

The representation of children as individuals with a personality of their own is a fairly recent development in art. In past centuries, the child was treated as a decorative motif or seen as a miniature adult. It is interesting to note that twentieth-century art is far from rife with depictions of young people. True, they repeatedly occur in the work of a broad spectrum of artists such as Matisse, Kollwitz, Dix, Bellmer, Beckmann or Balthus. Yet the content of this imagery cannot be said to advance any general anthropological statement. In this regard, pictures of children have shared the fate of the portrait, and of figure painting in general, which tend to be seen as purely anachronistic, or valued at best as interesting, but harmless, diversions. This is why the art of our time has produced no painting that could be set beside Runge's *Hülsenbeck Children*, a programmatic evocation of the new outlook on life enshrined in the nineteenth-century notion of the "romantic child."[3] Modern treatments of the subject seem to concentrate on fulfilling specific compositional tasks or expressing certain wishes or desires as part of the artist's family gallery, as mere studio props, as the result of a chance commission, or as an adjunct to some private mythology. This emblematic use of children is found in de Chirico (*The Child's Brain*, 1914), in Max Ernst (*Enfants menacés par un rossignol*, 1924), and even in the work of Marcel Duchamp, whose *Apolinère Enameled* (1916-17) features a little girl with a paintbrush, demonstrating how anachronistic painting has become – and so easy that even a child can do it. All of these examples offer interesting and stimulating aperçus.

With Picasso, this theme has broader ramifications. He challenges us to recapitulate the various stages through which our attitudes to children and our dealings with them have passed over the last few centuries. His work shows, as in a speeded-up film, various aspects of the historical process that led to an appreciation of childhood as a separate and distinct phase of

Claude 1950

human life. In discussing this attractive theme, so familiar and yet so strange, we should be wary of limiting it to a search for motifs, an enumeration of paintings in which girls or boys appear. Twentieth-century art does more than passively reflect the world of childhood; children have entered art in a sense that goes beyond considerations of subject matter. An identification with childlike forms of thought and behavior has clearly played a key part in modern artists' definition of their role. Spontaneous action has served as a strategy to break the fetters of tradition and academic convention. This strange and foreign element has employed numerous disguises, masking itself as aestheticism, or as techniques borrowed from the realm of games and pastimes, using tools and materials in deliberately inappropriate ways. The age of collage and montage, in which the trace of the artist's hand was replaced by quotation, invested these seemingly naive techniques with a new dignity. Here, too, Picasso led the way, with his early *papiers collés* and sculptures made of assorted objets trouvés. Modern artists sought to shed their sophistication and see the world with fresh eyes, adopting the values and meanings that children bring to experience as a source of originality and stylistic freedom.

The beginnings of this way of seeing reality in unfamiliar, exotic terms can be traced back to the Romantic era. In Runge's *Hülsenbeck Children*, there is a garden that unfolds as if seen through the eyes of the youngsters depicted. Adults are entirely absent. The theme of the picture reveals itself through the projection of an autonomous realm, the gateway to which bears a sign with the words "No Grown-ups Allowed." The children's very smallness explodes their surroundings, underscoring or eliminating aspects of reality. This exaggerated perspective, which attacked traditional habits of perception and undermined their hitherto unchallenged stability, had unprecedentedly far-reaching consequences. The evidence of the eye suddenly became relative. From here there is a path leading via *Alice in Wonderland* and the stories of Hans Christian Andersen to the paintings, drawings, and sculptures of Picasso himself, who frequently adopted the very low vantage point of a child. One example of this is the sculpture *Woman with Baby Carriage*, in which the child's moon face – uncannily like those of the Hülsenbeck children – confronts an enormously elongated mother with a "Gothic" appearance (p. 101).

The Artist's Daughter 1942

Picasso's example clearly played a crucial part in stimulating the interest of artists in children's perception as a model for their own practice. As the century's most radical protest against rationalism and the entelechy of autonomous art, Dada can also be seen in terms of this recourse to a pre-rational ideal. It is far from coincidental that the movement's very name was borrowed from children's babble, as a piece of programmatic nonsense with which the Dadaists set out to shake the earnestness and self-congratulatory snobbery of the art world. Tzara expressed his hope for a new beginning, symbolized by the figure of the child, by declaring that the Dadaists no longer even wished to know that humans had existed before them. After the noble savage of Rousseau, who pitted anti-intellectualism against education and enlightenment, after Gauguin's disappointing colonization of a geographically localized paradise, the marginal world of the child seemed to offer the only remaining path to the utopian realm of cultural "primitivism." This discovery was the outcome of a history of disillusionment: "One might think that when it was proved that the only remaining examples of primitive man did not meet the requirements of the cultural primitivist, that idea would have disappeared. Quite the contrary. A search was then made for a new exemplar that would be, if not the chronological *Urmensch*, at least the cultural. The outstanding results of this search were Woman, the Child, the Folk (rural), and later the Irrational or Neurotic, and the Collective Unconscious."[4] This regression into the prelogical, uncensored realm of dreams and free association later became the Surrealists' prime tactic of visual revelation. Here, too, Picasso's contribution was decisive. One thinks of the famous phrase, "The Eye exists in a feral state,"[5] with which Breton, in *Le Surréalisme et la peinture*, attempted to explain and interpret the radical thrust of Picasso's aesthetic revolution, his Cubism and *papiers collés*. No other artist's oeuvre focuses more sharply on childlike and primitive ways of thinking and seeing. Picasso not only depicted childhood, but attempted to transform it into an instrument and strategy of artistic production. Only in the work of Paul Klee does the interest in childlike qualities take on a comparable general significance.[6]

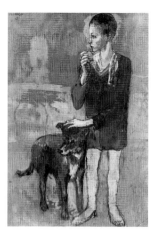

Boy with a Dog 1905

Right:
Child with Dove 1901

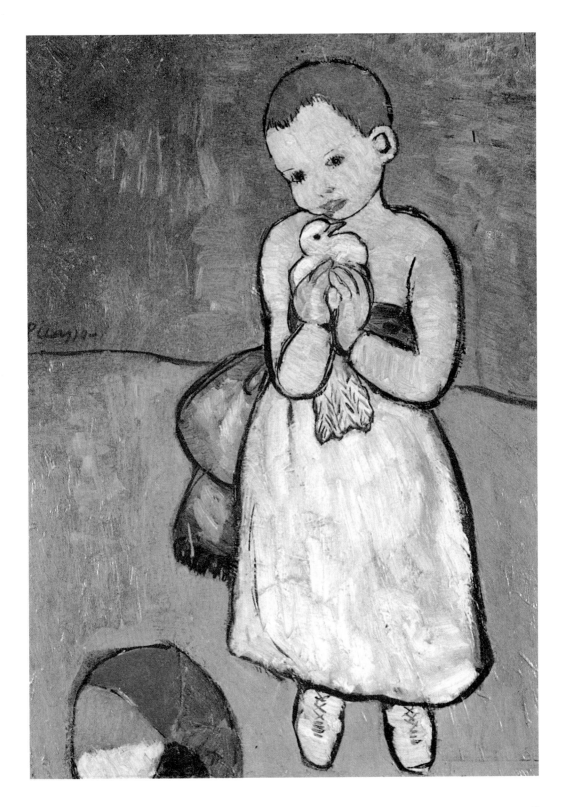

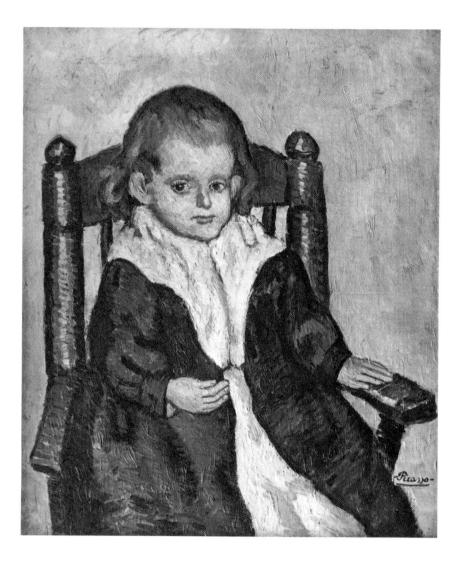

Child Seated in a Chair 1901

Right: Le gourmand 1901

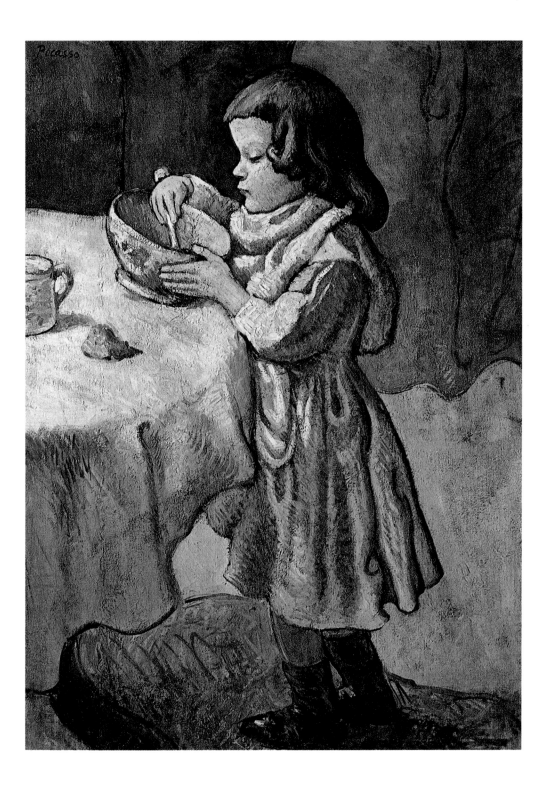

15

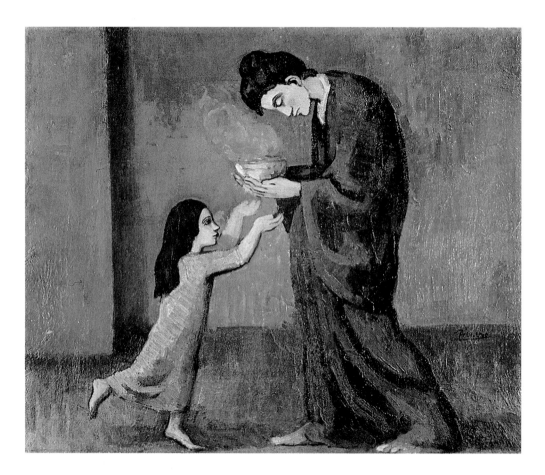

La soupe 1903

Right: Mother and Child by the Sea 1902

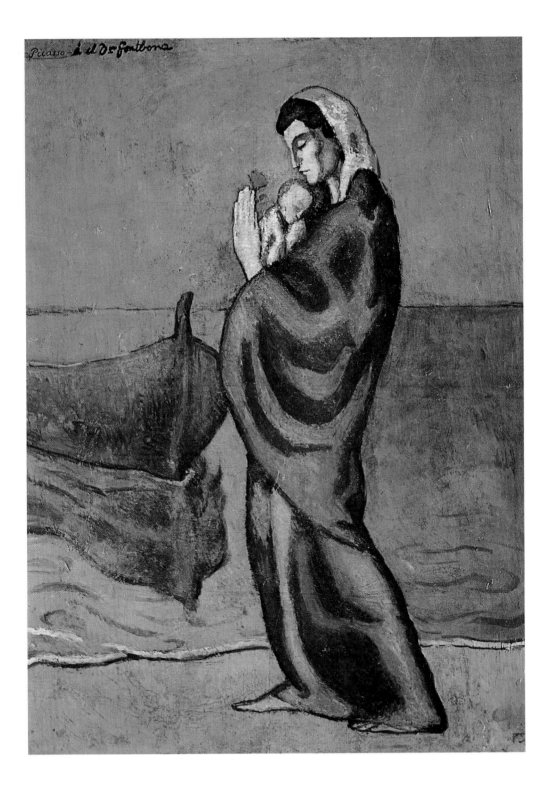

17

The Early Years and the Blue Period

Children, children with dolls, children in comical genre scenes – these are the subjects of several drawings done by the boy Picasso in Malaga and La Coruña. The motif crops up in even his earliest artistic attempts. However, it is to the young Picasso himself that our initial interest is drawn. I find myself reminded of a picture by Giovanni Francesco Caroto, a painter of the school of Raphael, called *Fanciullo con pupazetto.*[7] It shows a little boy holding a drawing he has done – a stick figure with an outsized head and spindly limbs of the kind all children draw. At first glance, the contrast is disturbing: it strikes the viewer as sharply discordant. Yet in the clash between the artist's sophisticated style and the child's natural awkwardness, which the artist has imitated, there is in fact a strange harmony – the authentic expression of childhood.

The portraits Picasso's father might have done of him in Malaga would scarcely have contained such dissonances. Young Pablo Ruiz's style, skillful and at times boisterously lampooning, had very little of the childlike about it. The fledgling artist rapidly acquired the professional touch, and, as countless sketches show, developed a figure stereotype and a virtuosity of execution that anticipated his first personal style. This confident leap into adulthood was encouraged by a highly ambitious family. This is significant: Picasso's later attitude to childhood was evidently divided, because he himself was never allowed to be a child. His precociousness and early maturity continued to inform his work all the way down to his Rose Period depictions of children. Here, it is interesting to find a statement by the artist himself, disclosing what could be called – by analogy with Freud's essay on Leonardo – a crucial "childhood memory of Pablo Picasso": "Unlike in music, there are no wunderkinder in painting. What you might consider a precocious genius is in reality the genius of childhood. It disappears at a certain age, leaving no trace. Possibly such a child will someday become a real painter, even a great one, but then he will have had to start over from the very beginning. I, for example, didn't have this genius. Not even my very first drawings could have hung in a show of children's art. They lacked the childish awkwardness, the naive quality, almost completely.... I passed the stage of these wonderful visions very quickly. At this young age I was drawing quite academically, so painstakingly and pre-

The Mistletoe Seller 1902-3

cisely that it horrifies me to think about it now.... My father was a drawing instructor and probably steered me prematurely in that direction."[8]

Portraits of other children are not found in the work of these early years, with one remarkable exception: an ambitious, large-format painting of Pablo's younger sister, Lola, together with his father, and a server at a first communion. Picasso's depictions of mothers with children, and several of his family groups, soon took on an elegiac tone that was far removed from the realistic approach of early compositions such as *Science and Charity*, or *First Communion*. His initial retention of picturesque details of local color reflected the lingering influence of his father and his classes

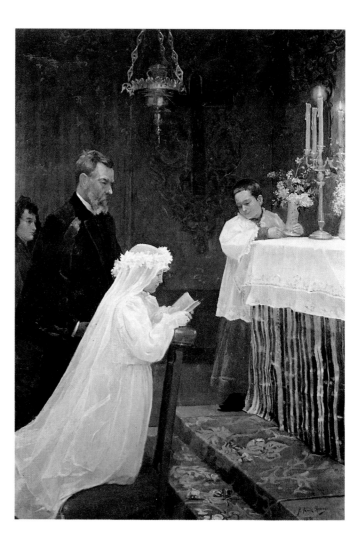

First Communion 1896

at the Barcelona Academy. After a brief phase of extroverted dandyism as a follower of the Catalan avant-garde, with its cult of Wagner and Schopenhauer, the young artist found a new set of bearings. Sketches from everyday life were replaced by a search for rarified, artificial moods, and a calculatedly eccentric style that flew in the face of naturalism. This tendency emerged at an early stage. In 1897 the sixteen-year-old Picasso wrote to a friend in Madrid: "Neither Nonell … nor Pichot, nor anyone else has achieved the extravagance of my drawing."[9] And a few years later, just as he was preparing to overthrow the entire system of realistic art, he added: "A tenor who sings a note far higher than shown in the score – me!"[10]

The Blue Period scenes featuring children – alone or in groups with their parents or siblings – are timeless compared to the depictions of this period. The children who appear in them often seem to exist in a floating, ethereal state. Perhaps the sole exception is *Le gourmand* (p. 15), striking a note of greedy sensualism that could be interpreted as a hunger for life. The description given by Félicien Fagus in June 1910 of a painting of children in the Vollard exhibition has little to do with Picasso's real concerns, and would seem to say a great deal more about what the Paris critic wished to see in a rather untypical work: "A real find, here: three little girls dancing, one of them with a green skirt over her white underwear, which has the tomboyish starchiness of little girls' nether garments."[11]

Joyless Children

The basic mood is set by a very familiar, and at first glance buoyant, picture, *Child with Dove* (p. 13), which Picasso painted in the phase of transition to the Blue Period. The little girl, her head slightly inclined, presses the dove tightly to her breast; or rather, she seems to grasp the bird as if it were the only emotional anchor she has left in the world. Unlike most of the children in the pictures of subsequent months, she still seeks to establish eye contact with the viewer. Even at this early stage we already find the introverted gesture, the denial of the physical, which was to dominate Picasso's art for the next few years. The child seems to withdraw into its own silhouette as if into a protective shell.

This image is a far cry from the view of children that had become established in France, England and Germany from the late eighteenth century onwards. The retreat of the family from public life into the realm of the private — which, as Philippe Ariès notes,[12] inevitably means excluding others — is an aspect entirely absent from Picasso's early work. The peace of the Victorian home or the aristocratic self-sufficiency that ensures children's and adolescents' security are nowhere to be found. Nor is there any trace of what one might call the phenomenology of childhood, the emergence of childhood as a state in its own right. Picasso's early work shows no sign of the optimistic faith in progress that bourgeois society projects onto its offspring, as the foundation of its own future. The context of the pictures in which children appear is generally shaped by a God-given, feudal order. Sentimentality and a tragic mood predominate. This is also the reason

Café in Montmartre –
the Flower Seller 1901

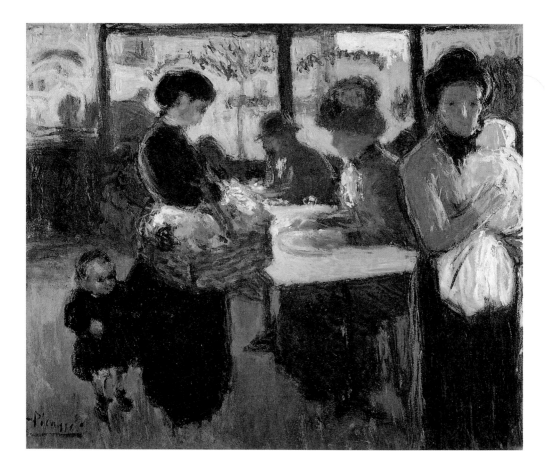

for the lack of any critical reference to prevailing social conditions. The few scenes in which public places and everyday events play a part (*Café in Montmartre*) remain picturesque asides. When a mother or child in one of his paintings extends their arms heavenwards, the gesture seems more of a religious evocation than an act of revolt. This is precisely what distinguishes his mothers and children from the revolutionary depictions of a Millet, Meunier, or Daumier. Daumier's *Third Class Carriage* may serve as an example.

The presence in Picasso's early work of vagabonds, beggar children, and other unfortunates, of whose social origins we learn almost nothing, suggests not so much a social message as a religious, metaphysical one. This is the result of the stylistic level chosen by the artist. The standardization of facial expression and gesture lends the figures a close resemblance to Romanesque or Gothic models. Depictions of the Virgin, allegories of Charity or the Visitation, and the gestures of the Annunciation reverberate in Picasso's early imagery, suffusing it with a sacred mood. Yet the genre traits of ecclesiastical art have been eliminated and the attributes reduced to a minimum. The few physical objects that do appear give no sign of ownership or belonging; in many cases, the figures hold them in the same way that martyrs clutch their stereotyped attributes. The figures are generally posed in front of a diffuse, summarily indicated landscape backdrop. The choreography of the unchanging ritual gestures and the broad, soft folds of the garments contribute more to the atmosphere of the paintings than do the faces of the figures. Here, Puvis de Chavannes, the monochromes of Carrière and the influence of Symbolism enter into a synthesis with the beggar-philosophers of Velázquez, with Murillo, and not least with Manet's *Old Musician*. There can be little doubting that these artists were more of a model to Picasso than Renoir or Denis, Vuillard or Bonnard – or even Munch, whose nihilistic, coldly clinical references to illness and death are echoed only briefly by Picasso's imagery at the time, in the composition *Last Moments* (1899).[13]

Children are fully integrated into this adult world. In most cases they appear individually, as the prototypical infant. They own no toys, and they play no games. Like straitjackets, their poses and contours hinder childish movements. While they may appear to be playing, they are actually rehearsing the gestures of their future occupation – begging, gathering, or helping. One

should remember that such motifs rely largely on the long tradition of depictions of pauperism, which extends from the Petrarch Master to Ribera, Callot, and Doré. As a commentator on social conditions records, "One sees children suffering from infirmities which were purposely inflicted on them to make them look even more worthy of pity and alms.... Every itinerant musician, every peddler and huckster, every showman and conjurer is accompanied by children – sometimes his own, sometimes abducted or purchased – who serve to boost his takings."[14]

The movements of Picasso's children are ceremonial, their heads frequently lowered, their expressions introverted and clouded by care. Their poses and gestures are those of adults, only on a smaller scale. It is as if life were intrinsically hostile to them: they never laugh, nor even show the trace of a smile. This chilling seriousness never quite disappeared from Picasso's depictions of children, not even from the classically "beautiful" versions of the 1920s, in which the relaxed insouciance of childhood is conspicuous by its absence.

The precocity of Picasso's children was noticed by the very earliest observers. As Adrien Farge wrote in 1902, "What eloquent symbolism there is in this strange figure! And how soulful the baby's pensive face appears – the face of an innocent already weighed down by the presentiment of life's cruelty. Seated on its high chair, in a robe of sumptuous royal blue, the child is already pondering...."[15] The portrait of the Soler family displays this absence of emotion in monumental form. Nowhere in this charmless group portrait is the pervasive silence broken. The relationship between parents and children is distanced and frosty. Each of the silhouettes is turned in upon itself: the parents are accompanied by miniature adults. No sign of intimacy interrupts the juxtaposition of related but discrete figures. The assembled members of the family stare straight out of the picture, their eyes meeting the possessive gaze of the artist. Even in this ambitious commissioned work, Picasso refrains from citing the accessories and furnishings, the sophisticated urban interiors that characterized the intimate scenes of the Nabis painters. He never assumed the role of a painter of bourgeois contentment; nor, for that matter, did he become a recorder of the condition of any other social group. This suppression of social comment radically distinguished his work from the art he encountered after his move to Paris. The gestures, facial expressions and costumes depicted by Degas or Toulouse-

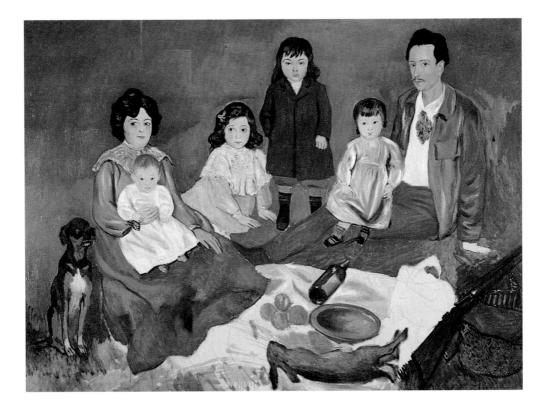

The Soler Family 1903

Lautrec were up-to-date, evoking the here and now, the realm of current fashion and custom. Still, there was one exception with Picasso, who came closest to being a "peintre de la vie moderne" in the Baudelairean sense when he turned to the life of prostitutes. In his pictures of *grisettes*, done in the early part of his time in Paris, the women are characterized by means of makeup, jewelry, and the accessories of the period. It is no coincidence that Picasso's involvement with the theme of the bordello directly inspired his radical leap into modernity in 1907, with *Les Demoiselles d'Avignon*.

The Child as Symbol

Every fashionable extravagance was expunged from Picasso's pictures of children in the early 1900s. These works also lack all trace of the psychological precision that characterized Degas's or Toulouse-Lautrec's treatment of the subject. Picasso's French colleagues toyed with the allure of children who were knowing beyond their years, and played on the suggestion of decadence. Such temptations had no effect on Picasso. As this already implies, his engagement with the contemporary and his definition of modernity soon began to rely on means that lay beyond iconography. As early as the Blue Period, children occasionally appear in a role which they were to retain throughout the oeuvre: that of a guardian angel to the adult world. Wherever children from outside his own family appear in his later pictures, they generally have this symbolic function. A case in point is the little girl, often with a wreath of flowers in her hair, who leads the blind Minotaur, the artist's favorite alter ego, through the labyrinth of the world (p. 68). Picasso returned to this motif in one of his very last drawings (p. 121), whose deep pathos seems to suggest a plea for redemption. At all events, it is clear that the contrast between the blind Minotaur and the innocent child in the works of the 1930s was prefigured by an early pictorial idea.

*The Blind Man and
the Girl* 1904

In the Blue Period, the image of the child serves as a point of contrast to emphasize disablement and physical illness. Childhood and classically balanced poses are set against decay and deformation. This characteristic fascination with the abnormal proved highly significant for the development of Picasso's art. The interplay of beautiful and repellent forms in his early work already foreshadows the tension which runs right through his subsequent oeuvre, with its stylistic hiatuses and revivals of earlier models. This discrepancy between malformation and pristine childish beauty was one of the aspects that had fascinated Picasso about Velázquez's *Las Meninas* (pp. 114-15), which he saw during his student days in Madrid. He subsequently populated the pictures of the Blue Period with the blind and the crippled, exploiting the reservoir of nature's own irregularities before going on to break the rules of art. The abnormal became the point of departure for a pictorial idiom that later rejected the canons governing the representation of the human body. The search for dissonance was a natural extension of Picasso's early antithetical style.

"There Was Never Any More Inception than There Is Now"

We have no record of any personal statement by Picasso about what so obviously preoccupied him during this period. The crucial clues to his thinking are concealed in the imagery itself and the role it assigns to children. In his dramatization of the eccentric, the child serves as more than a pleasing motif; it represents a concrete reference to a specific norm. Here, it is helpful to look at the journal *Arte Joven* (Young Art), the publication in which Picasso's attitudes and aims are perhaps most authentically expressed. Co-edited in Madrid by Picasso and Francisco de A. Soler

in 1901, the journal takes us to the months heralding the beginning of the Blue Period. Picasso is listed in the colophon as "Director artistico." Leafing through the issues of *Arte Joven*, all of which were illustrated by Picasso, one discovers a number of texts that provide a key to the interpretation of his striking new imagery. In Rusiñol's novella *El patio azul* (The Blue Patio), for instance, we find a convincing explanation for the depressive, somniferous blue in which Picasso now began to steep his world. In a quite unforgettable way, the author evokes the psychotic mood induced by the color, and exemplifies its significance by a tragic love story in which a painter and a "merciless" blue play the leading roles. Also published in *Arte Joven* was a momentous essay entitled "La Psicologia de la guitarra" by Nicolás Maria Lopez, who declares that "The guitar is feminine, in both the grammatical and the psychological sense.... Like a woman, the guitar yields easily. And like women, the guitar is capricious and difficult."[16] (The comparison between woman and guitar took on a decisive significance for the themes of Cubist art, and, as we shall see, for Picasso's depictions of children. Quite obviously, this metaphor anticipated the general transfer of one meaning to another on which the Cubist idiom was to rest.)

Finally, *Arte Joven* contains a number of references to the symbolic meaning that children held in Picasso's thinking. The journal's very title is indicative, and the words "childhood" and "youth" crop up again and again, invoking the widespread youth cult of the period, which celebrated the *ver sacrum* and the current of feeling that Walt Whitman, in *Leaves of Grass*, condensed into the phrase, "There was never any more inception than there is now." The year 1901 also saw the publication of *The Century of the Child*, a book-manifesto by the Swedish educationist Ellen Key. Believing that the future of humankind lay with its children, the author likened children to artists. As the motto for her book, which met with an extraordinary response in Europe, she chose a quotation from Nietzsche: "With your own children, you must make amends for being the children of your fathers."

Nietzsche was also cited in the manifesto published by the editors of *Arte Joven* in the journal's first issue. Picasso and Soler wrote: "The old, the feeble, the decayed, all that has crumbled from within, the bad breath of civilization is enough to destroy that which stands in our way." To this they contrasted youth, indeed perpetual youth: "All that remains, that has the power to

Harlequin's Family 1905

Right:
Actor and Child 1905

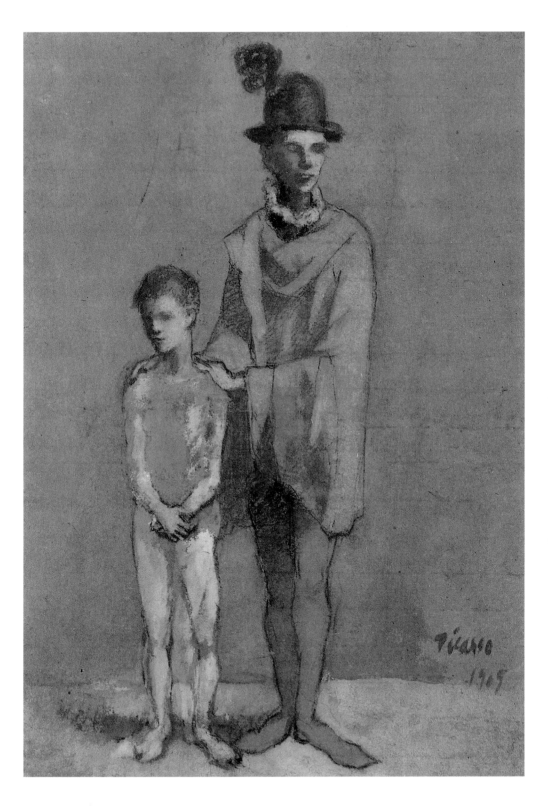

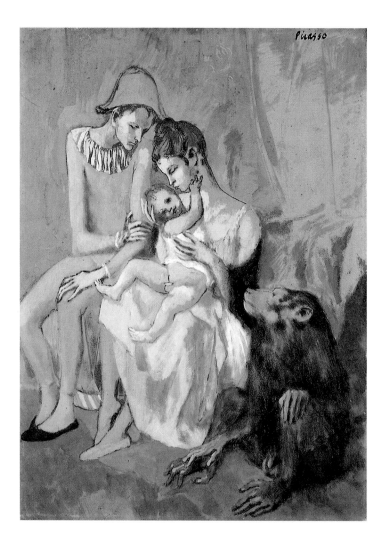

Family of Acrobats with Monkey 1905

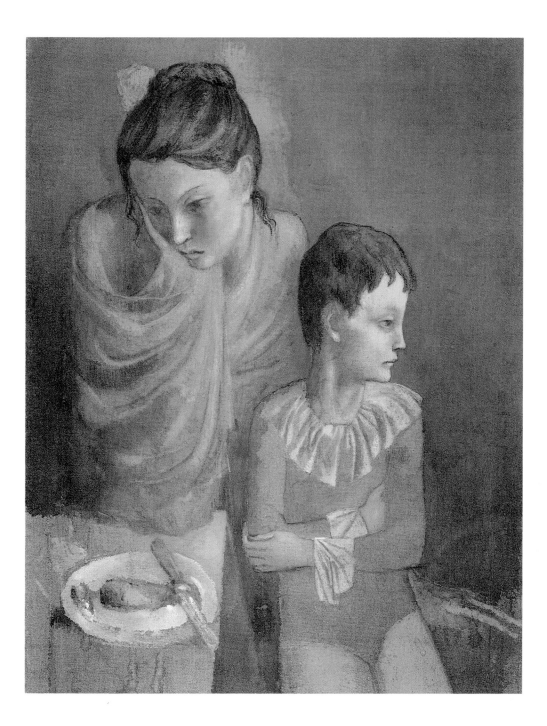

Artistes 1905

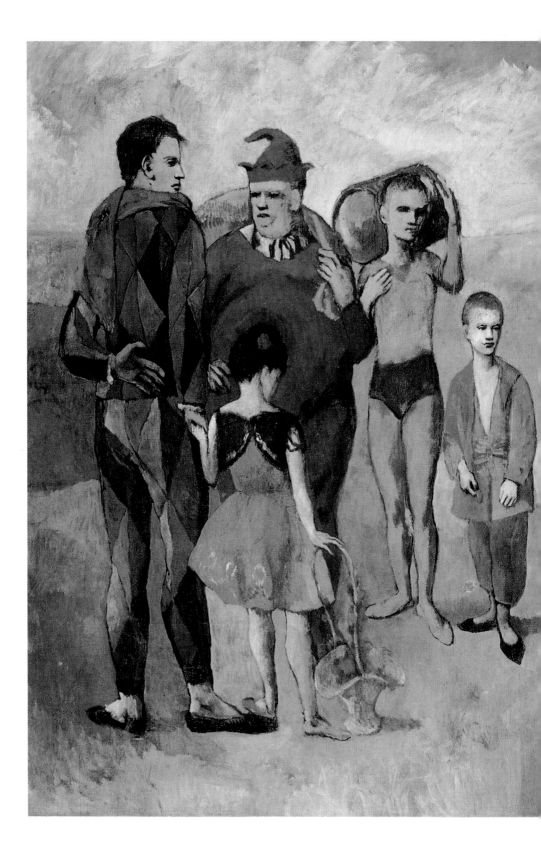

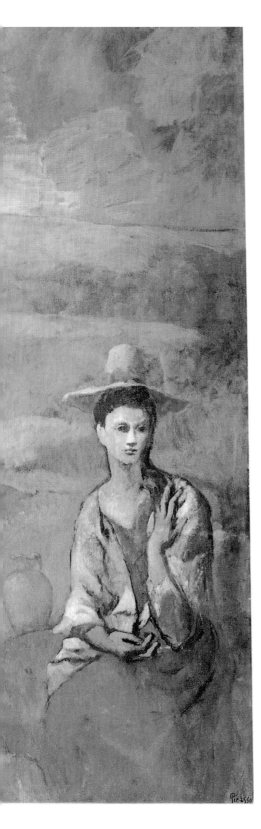

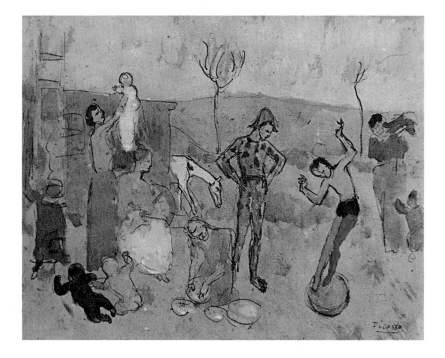

Family of Saltimbanques 1905

Right: Acrobat with Ball 1905

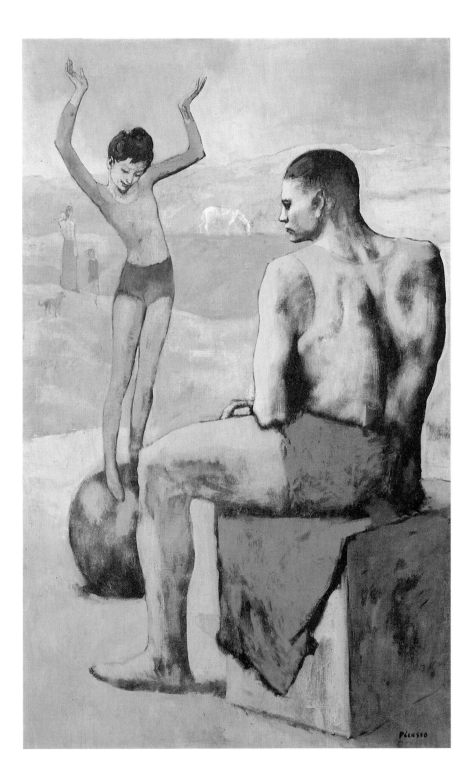

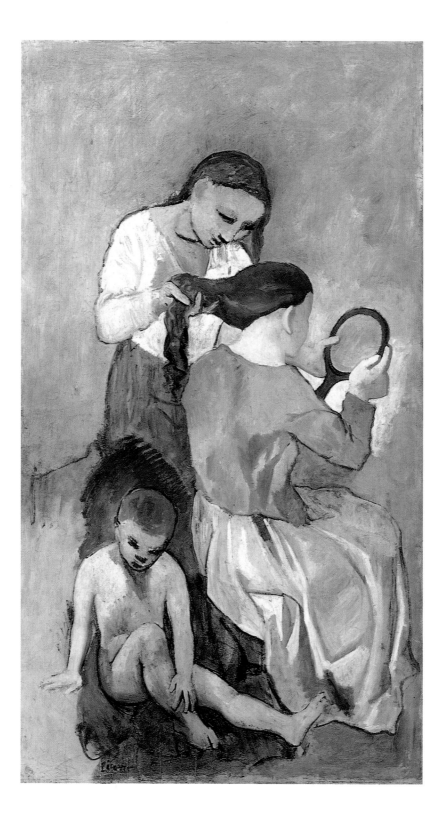

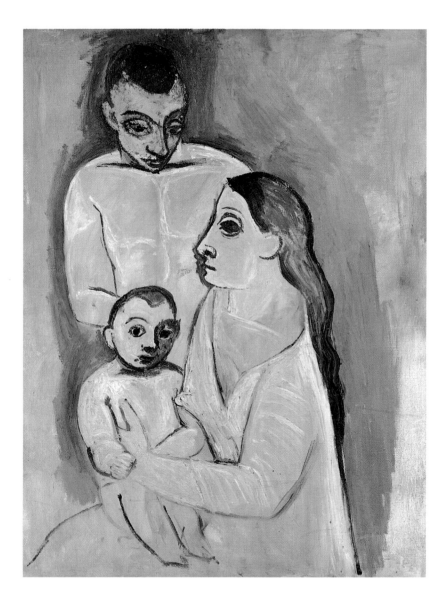

Man, Woman and Child 1906

Left: La coiffure 1906

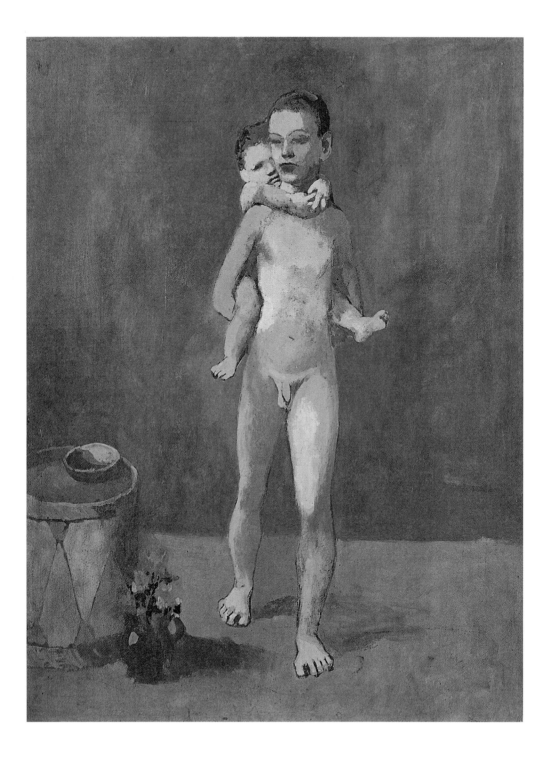

The Two Brothers 1906

weather the storm and stand firm against the pounding waves of the new, all this is not old: it is young, forever young, although it has already been with us for a thousand years." References to childhood are found in several of the articles in *Arte Joven*: in the anthology "Nuestra Estética, Ideas de Goethe," and in the last of three sonnets by Unamuno, which bears the title "Niñez" (Childhood). The presence of Unamuno is highly illuminating, since the Blue Period appears thoroughly pervaded by his pessimism. In the same vein, works such as *Amor y pedagogía*, a merciless attack on educators' exaggerated faith in science, also belong to the context in which the children of the Blue Period must be seen. Finally, a number of the ideas formulated by Unamuno in his celebrated volume of essays, *Del sentimento trájico de la vida en los hombres y en los pueblos* (The Tragic Sense of Life), reverberate through Picasso's imaginative world.

The Disguises of the Rose Period

In 1906, the depressive blue suddenly disappeared and was replaced by a different conceptual color range, whose delicate, translucent nuances immediately enlist the viewer's sympathy for the persons depicted. Compared to the work of the previous years, these pictures have a lightness that suggests an unproblematical Rococo world. The figures are more relaxed, although there is no evidence of any erotic interest. The relationships between mother and child, and among the children themselves, seem closer, the feelings deeper. Now and again, a hint of tenderness lends the scenes a more casual, carefree air. But behind all this there is a certain coldness, a hostility to physical contact, as evoked by Rilke in a line from the *Duino Elegies*: "... sometimes, in a fleeting interval, a loving face seeks to escape and fly from you to your seldom tender mother."[17] The mother-child relationship in these pictures is generally steeped in allusions to the Virgin and Child. The mannerist elongation of the figures' proportions lends the motif an air of preciousness that occasionally borders on pure sentimentality. Strictly speaking, the characterization of the figures remains as timeless as in the Blue Period. As Picasso repeatedly emphasized, none of the children in the Rose Period were based on a particular model. Nor, in general, can the figurative compositions of these years be said to reflect reality to any

significant extent. Even the few portraits of friends are stylized to the point of virtual unrecognizability. Alternatively, Picasso turns them into symbols and depicts them as child prototypes. In the major work of the period, *The Family of Saltimbanques*, he presented the retinue of his own personal court (pp. 32 - 33). The two boys in the center are thought to be André Salmon and Max Jacob in disguise.[18]

In this phase of his work, Picasso continued to avoid any direct depiction of bourgeois society. As in the Blue Period, his figures are embodiments of abstract concepts. Not surprisingly, Apollinaire and Rilke discovered in this artificial world a number of images that corresponded to the oblique, allusive nature of their poetry. It is enough to recall the famous introductory line to the fifth Duino elegy, which Rilke wrote with one of these paintings in mind: "But tell me, who are they, these travelers, these people a little more transient even than we ourselves?"[19] They were people, at any rate, who enjoyed no leisure. Picasso's concerns were a far cry from one of the principal themes of French Impressionism, the recreations of city-dwellers taking their *déjeuners sur l'herbe* or boating on the Seine. Behind the attitudes of apparent tranquillity and ease in his Rose Period canvases there lurked symbolic life and a metaphysical message.

The artist takes us into a marginal society, the subculture of sideshows and the circus. The task expected of each of its members is expressed in his or her costume. The slender silhouettes of the figures are no longer associated with poverty and need, but merely indicative of the hard training circus performers must endure. In this world of acrobats, jugglers, and weightlifters, children easily slip into serious, professional roles. Even the tiniest of them wear costumes and participate in the show, the arena populated by a melancholy group of outsiders. Condemned as they are to rehearse eternally in the backstage of life, these young harlequins and pierrots have little opportunity to play like normal children; thus the issue of the family and children's emancipation can hardly arise. The circus itself, as a *theatrum mundi*, provides the symbolic explanation for this. In these pictures, unlike in the vaudeville and circus scenes of a Degas, Toulouse-Lautrec, or Seurat, there are no audiences. Every figure plays an active role, but only that of a stand-in for real life. This even applies to the newborn children being held up by their mothers. They, too, are destined for a marginal life, devoid of the joys of childhood.

Little Girl Balancing on Horseback
1905

Primitivism and Childhood

Between the Rose Period, with its emotional, literary message, and Cubism, Picasso's work went through a transitional phase, in which he also made occasional pictures of children. Among the finest examples of the shift of emphasis seen at this point are the twin versions of *The Two Brothers* (pp.38, 41). Here, the disguises and costumes of the acrobat pictures have been discarded. The nude, a genre that featured only rarely in Picasso's earlier work, now began to fascinate him more and more. The naked body was not only a major new motif, it presaged an entirely new orientation. The naturalness of the poses and gestures in this phase brought a radical break with the ceremonial stiffness of the earlier pictures. The figures were freed of the psychological and literary ballast with which their stylized choreographies had weighted them down. Picasso temporarily adopted the ancient Greek *kouros* figure as a model. This paradigm shift is interesting, because fifteen years later, when he abandoned the Cubist idiom, it served as a basis for his turn to classicism.

The simple, unassuming presence of the figures in the canvases done during these few months established the framework for the emergence of Cubism. The element of characterization is reduced still further, and the pictures look even less like traditional portraits. The facial expressions of the Blue and Rose Periods – conventional masks of suffering, care, or melancholy – disappear entirely. Indeed, the artist seems to eliminate even the most general reference to the emotions reflected in the human face. This is true of his many pictures of Fernande, and also of his portrait of Gertrude Stein, which despite the great number of sittings he devoted to the model was eventually finished in the artist's studio: in a last-minute frenzy of activity, he reduced the face to a mask. The expressive dimension of the faces of this period can no longer be interpreted in normative, psychological terms.

In the summer of 1906, in Gosol, Picasso's break with his earlier subject matter took on a sharper focus. His *Man, Woman and Child* (p.37), a major work, dates from the autumn of that year. With this canvas, children put in their last appearance in his oeuvre until the end of the First World War. It was completed shortly after *La coiffure* (p.36), in which a little boy also figures. A comparison between the two compositions is revealing. Stylistically, the later *Man, Woman and Child* clearly foreshadows the

The Two Brothers 1906

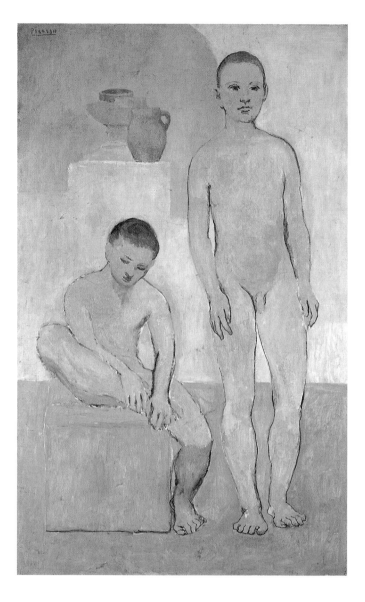

change of approach in late 1906 and early 1907, when Picasso em-
barked on the reduction of figures and faces to their structural
framework. The canvas already meets at least some of the criteria
for the early, expressive phase of Cubism: the composition is cut
off at the bottom edge, it unfolds in the plane, and a suggestion of
depth is counteracted by the introduction of elements parallel to
the picture surface. Details are largely discarded in favor of the
configuration of individual elements. The unfinished look, an in-

variable feature of Picasso's large-format compositions with several figures, now became part of his aesthetic strategy. The harsh, simplified contours and heavily outlined faces in this painting are totally at odds with the evocation of tenderness and sentiment that previously characterized his treatment of the theme. And at the cost of sacrificing psychological complexity for cliché, the sheer physical presence of the bodies is emphasized to the utmost.

Cubism:
The Search for a World without Childhood

At this point children disappeared from Picasso's work for many years. They and things associated with them had no place in the revolutionary Cubist idiom. Why should this be the case? Generally speaking, Cubism employed only a limited number of pictorial themes, of a largely static nature. Portraits were few and far between, and in the rare exceptions, characterization largely depended on one or two telling details and attributes such as a moustache or some object owned by the model – details that belonged to the adult world. The remaining Cubist paintings featuring the human figure were variations on the guitar or on musicians. A major clue to the significance of the anthropomorphized musical instrument is found in the essay in *Arte Joven* mentioned above.

At this point, Picasso's search for a pure image, cleansed of all accidentals, entered a crucial stage. Fascinated by the example of Cézanne, he sought a *nunc stans*, something to which he could cling in a world of dizzying change. Cubism's quintessential aim was to find a way of grasping reality, the world of objects, in timeless, a priori terms. It had no place for "young" forms, for the transitional stage symbolized by childhood. The idea of biological and psychological growth ceased to be of interest. Picasso's involvement with the organic, which had played such a prominent role in the Blue Period, with its emphasis on the distorted and monstrous, gave way to the construction of a world whose forms were crystalline, petrified and final. This raises the question whether a motif that Picasso abandoned during the decisive years of Cubism can really be counted among the significant themes of his work. One might tend to feel that his lack of interest in depict-

ing children at this point in his career makes the whole subject somewhat of a side-issue.

We mentioned earlier that, in the orbit of *Arte Joven*, Picasso had evolved a philosophy in which the ideas of childhood and spontaneity occupied a central position. At the beginning of his Cubist period, however, he turned instead to another form of childhood: the overtly childlike attitude known as aesthetic "primitivism." In place of the contrast between children's semi-awkward and semi-graceful movements in the generally static scenes of the early period, in place of the observation of childish, immature gestures found in the Blue and Rose Periods, there came a turn towards non-European art. The crucial paradigm shift evidently occurred at the time when Picasso was working on *Les Demoiselles d'Avignon*, his grouping of five prostitutes. Once again he opted to make an intellectual sacrifice of the kind discussed in the writings of Unamuno – and of an extent which no artist before him had dared to contemplate. Unamuno spoke of the greatness of people who were prepared to make themselves look ridiculous, referring to the example of Don Quixote. Perhaps the best commentary on Picasso's anti-intellectual position at this time is found in the notes of Picasso's friend and spokesman, Jaime Sabartés, who talks about the artist's yearning for childhood and repeatedly alludes to the effort of conscious regression which Unamuno encouraged artists to make.

The reactions to *Les Demoiselles* leave little doubt that Picasso succeeded in his aim. They were summed up by a key eye-witness, the dealer and critic Daniel-Henry Kahnweiler, who declared, "The picture he has painted appeared insane and monstrous to everyone."[20] Sabartés, in turn, argued that there was a stylistic intention behind the distortion that Picasso's horrified contemporaries saw in his recent work. "At the same time," he wrote, "we obstinately uphold the thesis – for it was Picasso's own idea – that the true artist must be an ignoramus: knowledge hampers him, clouds his vision, and diminishes his power of expression, because it leads to a loss of spontaneity."[21]

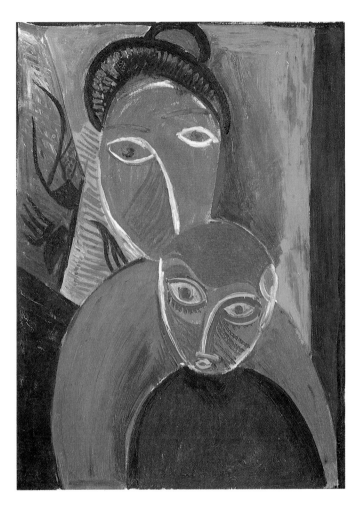

The Motif Returns

We explained the fact that between 1906 and 1919 Picasso pro-
duced no further pictures of children by saying that the Cubist
idiom required an iconography cleansed of every illustrative or
sentimental theme. One might add that the Cubist and Futurist
artists who subsequently adopted Picasso's and Braque's discov-
eries as ready-made solutions had just as little use for the motif.
This even applies to La Fresnaye. who dealt with a number of nar-
rative themes in his Esperanto version of Cubism: even in his *La
vie conjugale* of 1913. with its echoes of genre painting. children
have no place. One of the few exceptions to this rule is *Girl Run-
ning on the Balcony*: by Giacomo Balla.[22] In this 1912 canvas the

artist visualized the sole characteristic of childhood that seemed important to a Futurist's eyes: restless motor activity, symbolized by multiple, running legs.

However, although children disappeared from Picasso's paintings during Cubism's "heroic" period, this does not mean that the new idiom proved lastingly impervious to the theme. As with his other subjects, Picasso later approached the theme with all the various stylistic means at his disposal, including those of Cubism. To sum up our findings so far: Picasso's concentration on a small number of instantly recognizable themes (the still life, the landscape, the woman with guitar) supplied the necessary basis for the gradually increasing complexity and abstraction of the Cubist idiom during its first, analytical phase. A greater range of themes, or subjects that told ramified stories, would have obstructed this process. This, however, does not hold to the same extent for the subsequent, synthetic period of Cubism.

After 1917, the thematic restrictions that Picasso had imposed upon himself at the inception of Cubism began to lose their categorical stringency. The child motif consequently resurfaces in this later phase. In 1919 Picasso painted *Girl with a Hoop*, as part of a series of works in which he experimented with various new themes. The picture clearly illustrates some of the problems he faced when translating realistic motifs into Cubist terms. The geometrically stylized face of the girl gives no clue to her age. So, apparently feeling a need to define her more clearly as a child, Picasso added an attribute, the hoop she clutches in one hand. In a subsequent picture he resorted to a photograph – taken from an advertisement for a photographer's studio – to produce a surprising new version of the *First Communion*. In addition to this work, which more or less faithfully reproduces the sentimental portrait of the two children, he also did a Cubist version that closely copied the proportions of the figures and the existing composition (pp. 48-49). He even included a few picturesque details from the photograph. [23]

Picasso never based his imagery on direct observation of nature. Not only when using photographs, but in his other pictures, too, he worked from a mediated reality. In designing the curtain for the ballet *Parade*, Picasso employed a photograph of an aquatint by Vianelli. At a time when he was gradually abandoning the conceptual approach of Cubism, his recourse to documents of this kind is especially interesting. It is as though he felt

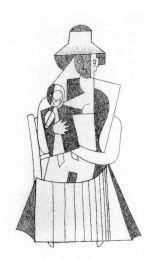

Little Girl with Doll 1917

Right:
Girl with a Hoop 1919

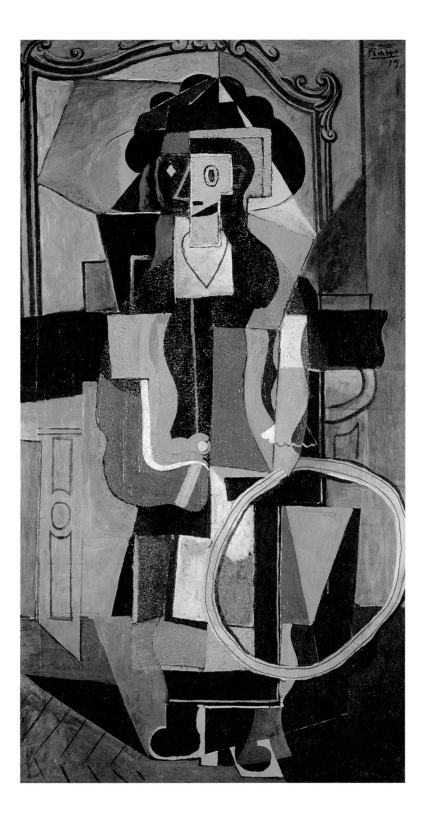

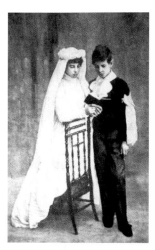

the need to find a new set of bearings within reality, and was more dependent than ever before on a mediated vision. This also applies to his renewed interest in the motif of children. For in every case where he relied on a photograph or other visual document, he adopted the expression and details of the original almost literally. Picasso's reliance on photographs during these years, though infrequent, introduced veristic traits into his work for the first and only time. His employment of this medium helped to counteract or reduce the monumentality of his neoclassical treatments of the theme. But although he borrowed details from photographs, he only did so in small doses. Picasso was not interested in illustrating everyday life; his principal concern was with a symbolic heightening of reality.

A different approach to the problem is illustrated by *Little Girl with Doll* (p. 46), a neo-Cubist drawing, as it were, which in

Les premiers communiants 1919

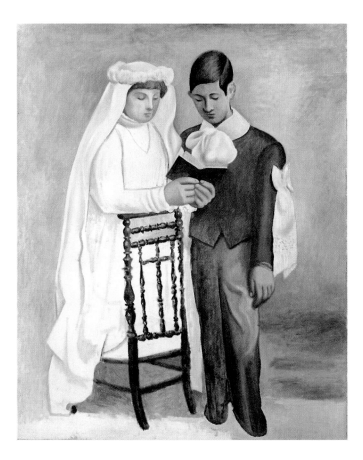

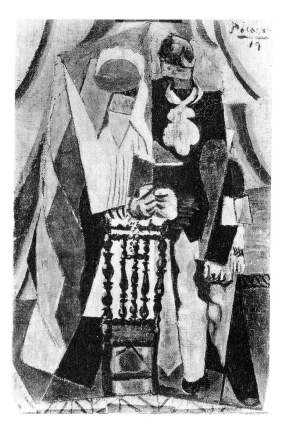

fact probably depicts a mother and child. It, too, fits into the phase of dissolution in which various styles are used concurrently and given equal status. Clearly recognizable signals are blended with a conceptual, geometric stylization. The baby's spherical head evokes the purely childlike, in a similar way to the often humorous Cubist-style abstraction used by Klee to suggest the world of children and their perceptions of it. Picasso continued to develop this motif in a series of further drawings. In another version of *Mother and Child*[24] he looked back to Renoir. At approximately the same time, Picasso also depicted several groups of grown-ups and children, some of which distinctly recall the acrobat and harlequin scenes of the Rose Period.

These works followed the period in which Picasso collaborated, in
Rome and Naples, with Diaghilev's Russian Ballet on its produc-
tion of *Parade*. It was here that he met his future wife, Olga.[25]
After his 1917 journey to Italy, classical themes began to play an in-
creasingly prominent role in his work. Almost by definition, these
are subjects that rely heavily on closed contours and compact
volumes. To understand why Picasso confined himself to a few,
timeless themes at this point, it is useful to recall that he had done
so once before, in 1906, when he temporarily toyed with the clas-
sical figurative canon during the transition from the sentimental
Rose Period to Cubism. This recourse to an idealistic form of art
anticipated the basic drift of Cubism, which was similarly con-
cerned with developing a set of pictorial means from which all
accidental, and incidental, traits were expunged.

Head of a Boy 1923

Picasso's turn towards neoclassicism, a new model that preoc-
cupied him for several years, was also to have consequences for
his depiction of children. But first, by way of background, let us
recall the general state of affairs in European art. The avant-garde
had withdrawn from its more remote outposts, and begun to close
ranks under the banner of a *retour à l'ordre*. Having grown skep-
tical of their extreme prewar positions, artists like Picasso,
Matisse, and, in a certain sense, Derain, adopted a norm which –
without calling painting into question per se – corresponded to
events on the Dadaist front. Where the Dadaists ironically de-
clared that Dada was not modern, Picasso returned to a figurative
style that required great skill and a knowledge of tradition to
make it convincing.

All the same, no other artist of the day was capable of injecting
so much of his personal style into the old neoclassical canon. Un-
like the exponents of *Neue Sachlichkeit* or the Novecento artists,
who made the first postmodern attempts to revitalize Greek and
Roman or Renaissance art, Picasso never set up an actual model
or ideal to work from. He had no part in producing the innumer-
able Virgins with Child which enjoyed such great favor at the
time. With him, neoclassicism very rapidly became an intellectual
matter in which the issues of modern art continued to play a cen-
tral role.

His bold new colors are a case in point. As always, in choosing
his palette Picasso gave no particular weight to local color.

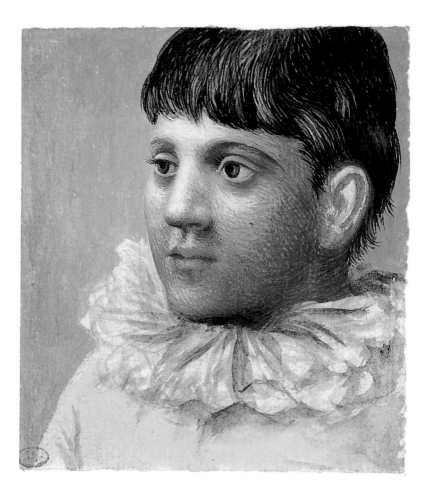

Portrait of a Child in Pierrot Costume 1922

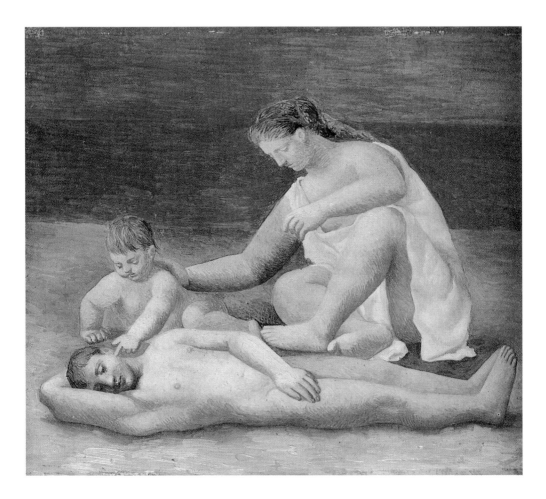

Family at the Seaside 1922

Right: Motherhood 1921

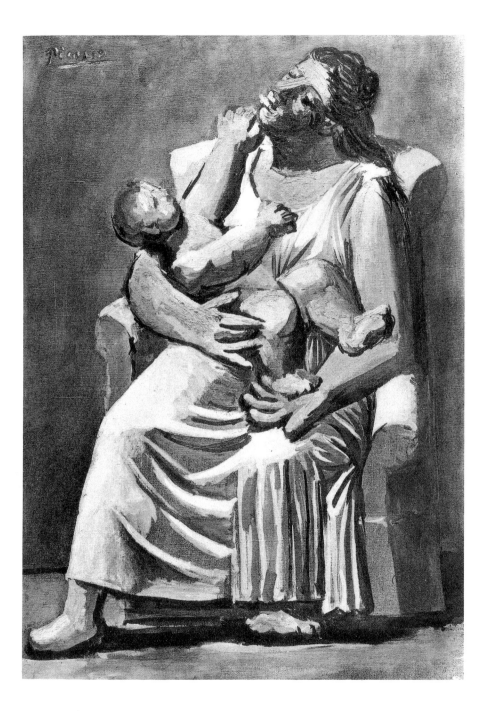

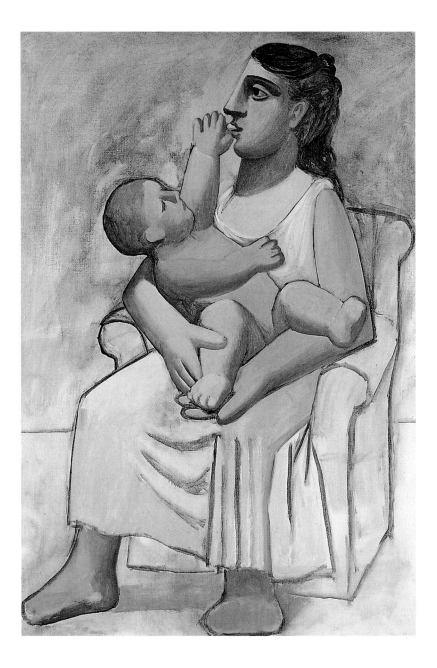

Mother and Child 1921

Woman and Child at the Seaside 1921

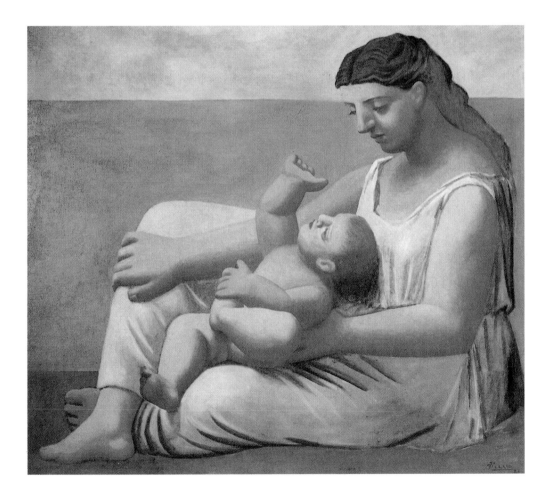

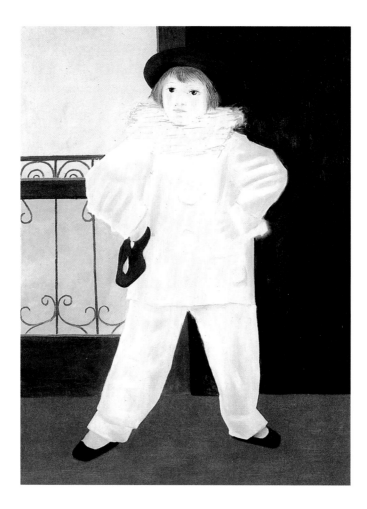

Paolo as Pierrot (the Artist's Son) 1925

Right: Paolo as Harlequin 1924

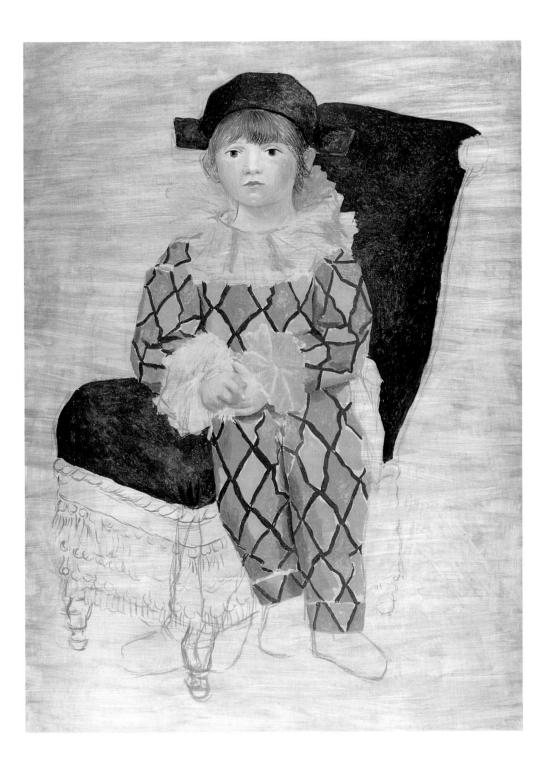

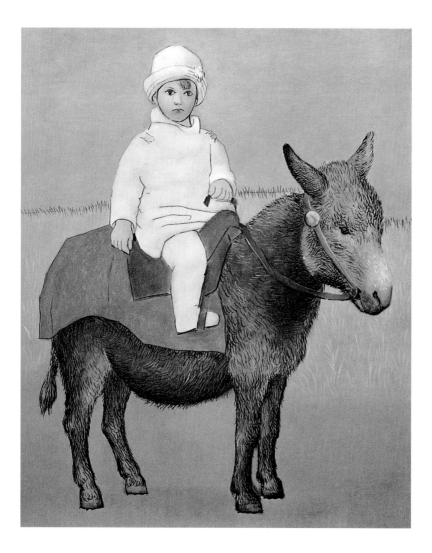

Paolo, the Artist's Son, Aged Two 1923

Right: Paolo Drawing 1923

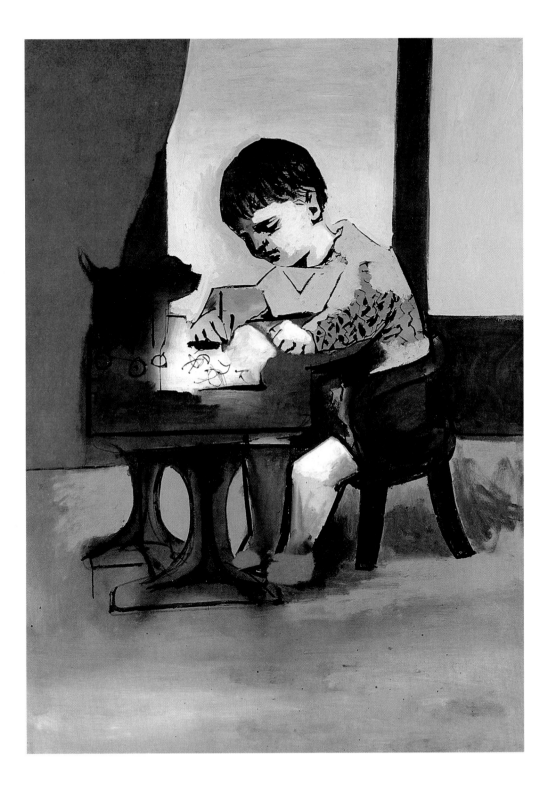

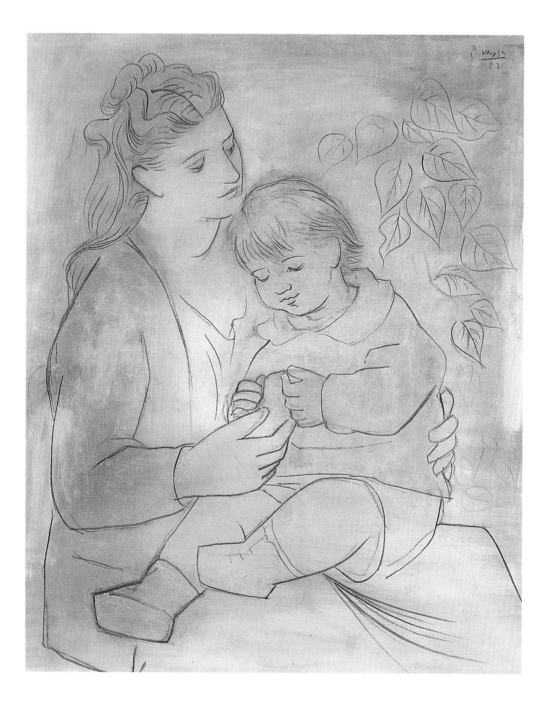

Mother and Child 1922

All of the previous periods had been characterized by a single pervading hue – one thinks of the Blue and Rose Periods, the ochre of the months in Gosol, and the grayish-brown tonality of Cubism. This time, the artist initially opted for a reddish brown that compellingly suggested the insistent presence of young bodies and fresh, glowing skin.

Neoclassicism determined Picasso's choice of timeless, transhistorical subjects. These included variations on the theme of mother and child (pp. 53–55), many of which were done even before the birth of his son, Paolo. All these pictures have an air of monumental stasis. In the rendering of facial features and garments, the general triumphs over the particular, evoking a world in suspended animation. The impassivity of expression found here recalls the Rose Period. Only the children introduce a certain sense of movement, and even their activity is set in an unchanging iconographical framework. Their mothers are generally caught in a frozen, wholly stylized pose, as if acting out a role on the stage of art history. The scenes are dominated by elements borrowed from Greek and Roman art, including drapery with elaborate folds.

On February 4, 1921, Picasso became a father for the first time. This key event in his life had no immediate impact on his painting. True, one finds the occasional group of father, mother and child – the father usually asleep, and the child making a tender gesture that mitigates the rigor of the composition – but these are bucolic scenes that have little to do with the reality of ordinary domestic life. Picasso particularly favors the seaside as a setting (p. 52), and intersperses his depictions of the family triangle with love scenes.

Even if these figures do allude to his own family, Picasso has refrained from giving the heads any recognizably individual features. The canvases yield no information about his household on Rue de la Boétie, and the viewer searches in vain for indications of domestic peace or family harmony. Picasso apparently felt reluctant to depict his infant son, Paolo: the paintings and drawings of the period avoid all physiological detail. Consequently, everything characteristic of childhood is omitted – childish gestures, awkwardness, crying, are nowhere in evidence. This is striking when one considers the enormous amount of attention Picasso later devoted to recording the growth of his other children. At this early stage, he preferred to sublimate his infant son's physical

being, transposing it into the terms of an ideal model supplied by museums: the infant Jesus in his mother's lap. Many of the pictures from this period testify to a fascination with the images of the Virgin and Child and the massive, nurturing goddess-matriarchs of Greek and Roman art.

The Courtly Portrait of His Firstborn

Paolo riding a donkey 1923

Several years passed before Picasso was able to portray his son with individualized features and in a more ambitious composition. The process was like an initiation rite, or a ceremonial act announced with a flourish of trumpets: "Ladies and gentlemen, Mr. Pablo Picasso will now paint his firstborn son." He depicted Paolo alone, without his mother. This confrontation could be said to repeat, with reversed roles, the dramatization of shyness that had occurred twenty-five years earlier in Picasso's relationship to his own father. The artist based his approach on great models from the past. One finds oneself reminded of the famous child portraits of Velázquez, of Rembrandt's little Titus at his writing desk, or Goya's *Don Manuel Osorio de Zuniga* (1788). Some of the costumes worn by the infant Paolo were quoted from Picasso's own earlier work. It is as if his father were playing a game of "Rose Period" with him. The boy appears in a succession of roles: riding on a donkey, as a harlequin, as a pierrot. There is little sense of motion, let alone turbulence, in any of these compositions. This is scarcely surprising: it was not until the mid-1920s that Picasso roused his figure groups out of their measured, choreographed movements by introducing quicker rhythms.

In one of his portraits of Paolo, Picasso relied on a photograph, as in his first portrait of Olga. The artificiality of the pose which the photographer had compelled the sitter to adopt apparently intrigued Picasso. We have already seen an example of this fascination in *Les premiers communiants* (p.48). Here, one must bear in mind that such studio poses had less to do with the objective representation of reality than with established artistic convention. The photographer himself had already employed a model taken from museums and galleries to arrange the figures. Picasso's beautiful paintings of Paolo convey the impression of looking at the subject through the wrong end of a telescope, setting it at a distance: his son has the appearance of a charming

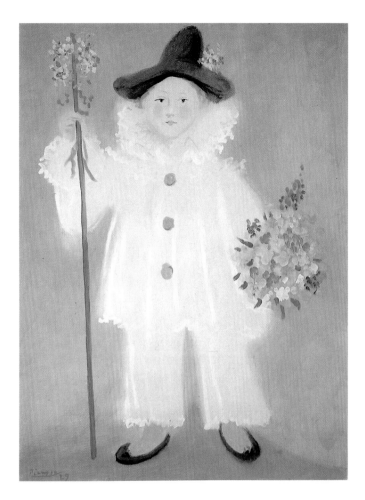

Paolo, the Artist's Son,
as Pierrot 1929

miniature adult. There is a touch of courtly decorum in the way
he sits. silent and upright. on the edge of a Louis Quinze chair. It
is interesting to note that. in this "official" portrait for the family
album. Picasso posed his son in the same chair in which Olga had
sat for him in 1917.

This markedly unchildlike image. in which posture and bea-
ring play such an important role. surely had a great deal to do
with Olga's sense of social status. As the sophisticated daughter of
a Russian general. she made every effort to pry Picasso out of his
bohemian environment. When their son was born. his estrange-
ment from his former associates became complete. Many recollec-
tions of earlier friends who now experienced the Picasso family's
bourgeois life-style record the change. To cite only one example:

"When Picasso became a father, Max paid him a visit. As he left, he said he had not been received with the same degree of warmth as in the past. 'The baby has turned his head,' he added."[26]

Picasso seems to have accepted this new situation quite passively. Instead of coming directly to terms with the changed reality of his life, he apparently chose to retreat into the formalized idiom of his art. At first he was able, at least, to depict the mother-child relationship, in terms of a set formula. Yet as soon as the opportunity for real observation presented itself, Picasso abandoned even this vision of motherly love. From the point at which he began to portray his son, he depicted him alone.

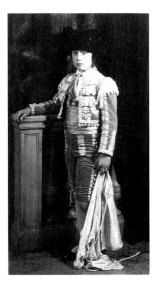

Paolo dressed as a torero ca. 1930

Private Life and Mythological Projections

A further observation suggests itself. Picasso, the father, systematically absents himself from these pictures. The three-figure groups mentioned above were all based on mythological models, and showed no portrait likenesses. This is the case throughout Picasso's entire oeuvre. One can sift through its thousands of paintings and drawings without discovering a single self-portrait of the artist with one of his children. It is as if father and children had remained on opposite sides of the mirror. The single, telling, exception is a small series of India-ink silhouettes done in the 1950s. They show the profiles of Picasso, Françoise, Paloma, and Claude – but as ineffable phantoms.[27]

Paolo vanished from Picasso's art shortly after the portrait was done. For some time, children were to be seen only in mythological groups, set in the context of beach scenes; portraits did not reappear until the late 1930s. Maya features in numerous drawings and in a series of paintings that differ markedly from the formal style in which Picasso depicted Paolo, and occasionally contain precise observations of typical children's behavior. Still, Picasso continued to shut himself out from this new life. He left no family portrait to posterity.

In a number of further paintings and drawings – *Child with Pacifier under a Chair* (p. 83), *Woman, Cat on a Chair, and Child under the Chair* (p. 82) – individual traits are obscured by networks of lines resembling spiderwebs. Picasso's portrayals of Marie-Thérèse, Maya, and himself are invariably encrypted and

idealized. The idyllic gouaches collectively titled *Man with Mask, Wife, and Child* (pp. 70–71) take us into a distant, mythological realm. The young, bearded man wears the Minotaur's horns, while the child lies asleep in a baby carriage. Such strikingly anachronistic elements belong to the poetic, post-surrealistic figurative style of the period. A dreamlike, unreal atmosphere pervades these scenes. They could be characterized by the evocative statement quoted at the head of our first chapter: "Although I come from far away, I am a child, and I want to eat, and to swim in salt water."

Picasso wrote these words just a few months before Marie-Thérèse Walter gave birth to their daughter, Maya, in September 1935. The allusion to prenatal security, to floating free of care in the amniotic fluid, had its source in an actual, family situation. At this moment in his life, Picasso faced one of the worst crises he had ever experienced. He felt terribly threatened and harassed by Olga. His imagination was fired by the idea of returning to the womb, of identifying with the baby Marie-Thérèse was carrying. The texts he wrote at the time indicate that childhood appeared to him as a tantalizing paradise from which he himself had always been excluded.

The Dead Children: Guernica *and* The Charnel House

In the late 1930s Picasso continued to employ the expressive idiom he had developed in the monumental *Guernica*. The presence of a child in this painting underscores the fact that his treatment of the subject was by no means restricted to idyllic phases and genre-type aspects. *Guernica* conveys an overall impression of undefined threat and horrified panic. Only a few, striking, details provide clues to its encoded antiwar message. Foremost of these are the weeping women, and the dead child, an image that appears here for the first time in Picasso's oeuvre. He depicted this truly shocking motif, which harked back to Poussin's *Massacre of the Innocents* and Eisenstein's *Battleship Potemkin*, in a number of variations. The extent to which it concerned him is indicated by the fact that, from this point, children appear in every one of his "history" paintings. *Guernica, The Charnel House* (p. 88), *Massacre in Korea* (p. 75), *War and Peace*, and *Rape of the Sabine*

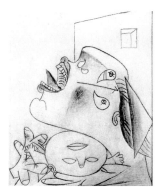

Study for Guernica *1937*

Women (p. 89) all include dead children, or children in imminent danger. The infants dangling lifeless in their mothers' arms, or the tiny corpse in *The Charnel House*, laconically evoke the inconceivable. Picasso's indictment rests on a very few, heartrending details: tiny lifeless fingers next to the mother's great, cramped hand; a baby's thumb, still in its mouth even in death. The fate that has befallen these children and women brings Picasso's pessimistic view of the world into sharp focus: the message of the paintings is clear and unequivocal.

Apart from their role in the history paintings, children remain cocooned in their own safe little world. This even applies to the time Picasso spent in Paris during the Occupation. In 1939, when war broke out, he escaped to Royan, on the Atlantic coast. A series of death's heads and still lifes with animal skulls that show an unprecedented degree of physical deformation date from the weeks he spent there. Also done at the time were two paintings of seated little girls, and *Boy with Lobster* (p. 87). These compositions exhibit a degree of distortion that places them outside the entire framework of Picasso's previous approach to the depiction of children. How can this obviously deliberate break with artistic convention be explained? *Boy with Lobster* constitutes possibly the most enigmatic image of a child in the entire oeuvre. I should like to propose an interpretation that puts this challengingly scabrous picture in an emblematic context which goes beyond that evoked by the obvious seaside attributes of boy, lobster, and squid.

First, let us turn to Dalí and his famous autobiographical picture, *Spectre de la libido*, painted in 1934. His detailed commentary on this self-portrait of the artist as a child reads: "The little Dalí is terrified by the giant specter of the eternal female, at the painful hour when it takes its bath." Dalí, as a little boy, is clad in a sailor's suit. Picasso was evidently acquainted with the picture, because a few years later he replied with a version of his own, a boy holding a butterfly net and wearing a sailor's cap whose band bears the bold inscription "Picasso." Thus we see two little boys by the seaside; one personal, autobiographical note replying to the other.

From this, the conclusion may be drawn that Picasso's involvement with the subject continued, and deepened, in the later *Boy with Lobster*. The boy whose penis is threatened by the lobster and squid can be seen as an allusion to Dalí's castration anxiety, a fear that pervaded so many of his works.

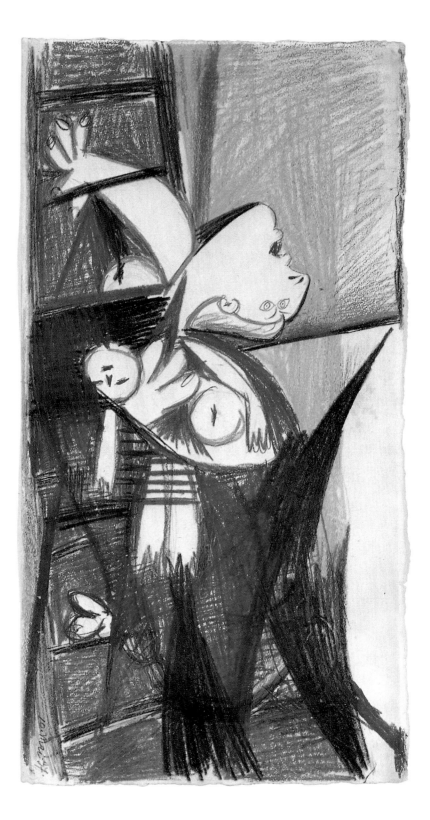

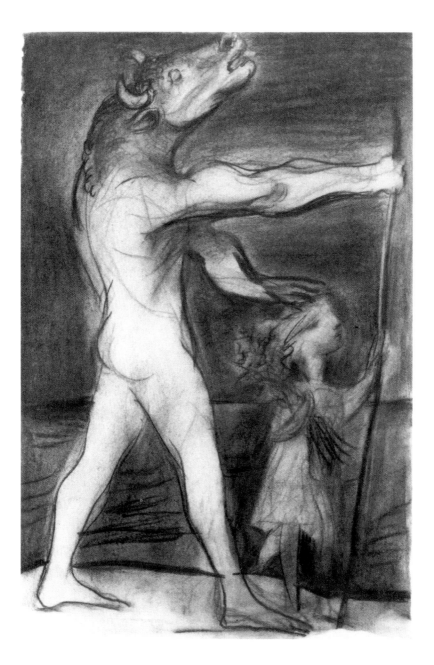

Blind Minotaur, Led by a Young Girl 1934

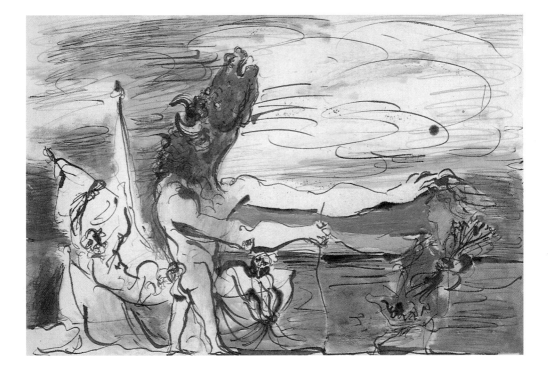

Blind Minotaur, Led by a Little Girl 1934

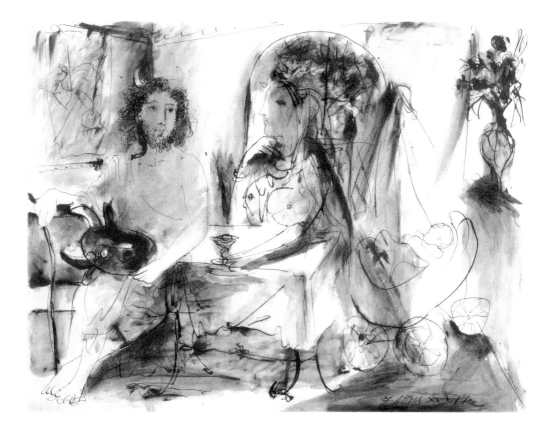

Man with Mask, Wife, and Child in Its Cradle 1936

Right: Man with Mask, Wife, and Child on Her Arm 1936

70

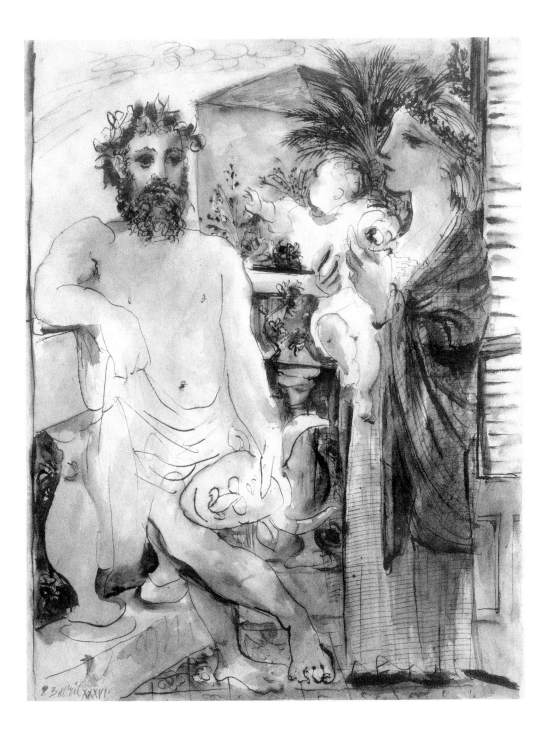

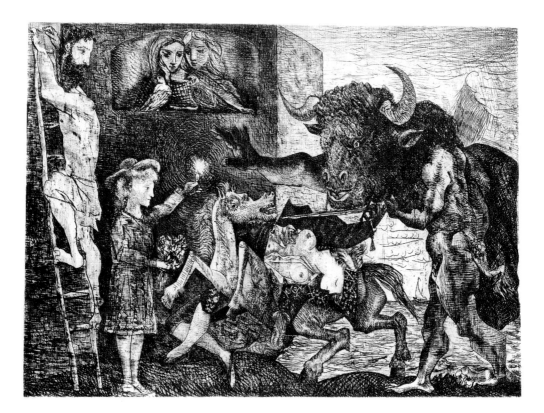

La Minotauromachie 1935

Viewed in this light, Picasso's astonishing psychoanalytical reference to a neurotic obsession could be considered a final example of his involvement with Surrealism. Otherwise, after the completion of *Guernica*, every trace of Surrealist iconography had disappeared from his work.

In the images of children he painted and drew in Royan, Picasso subjected the figures and faces to extreme distortion. The approach is surprisingly different from that in the several portraits of Maya with a toy boat or a doll which Picasso had done the year before. Here, Maya's features are still recognizable; the pictures are definitely portraits of the artist's daughter, who is further characterized by her own dresses and toys. The expression of eyes and mouth, despite their unnatural positions, have a happy, childlike character. Though there is no scope for detailed discussion of the variety of expression found in this series of child pictures, the more markedly deformed heads seen in Picasso's Royan works call for brief comment.

Striking as these distortions are, I am convinced that they convey no psychologically negative message. With his radical stylistic approach, Picasso always found it difficult to express content of a negative or evil nature. I have attempted to illustrate this with reference to the cycle of etchings entitled *Dream and Lie of Franco*.[28] In order to identify Franco with the principle of evil, Picasso created a configuration that was essentially foreign to his art – a grimacing mask with the dictator's features. As he employed this in an unaltered, stereotyped form throughout the cycle, it took on a degree of sterility which – in the context of his other work, with its protean versatility – did indeed suggest evil and cruelty. Yet as a glance at Picasso's surprisingly distorted images of children indicates, this device was equally capable of conveying a positive message. The face in *Child in a Chair* (p. 79), unlike many of his other images of children, even wears an unmistakable happy smile. And the pose is definitely and delightfully that of a child, if a slightly naughty one. Such observations lead one to challenge the view that the deformation found in Picasso's pictures of children at this period necessarily expresses a repellent content or represents an allegorization of war.

To his contemporaries, however, the liberties Picasso took with the elements of the human body seemed entirely unacceptable. In Picasso's pictures of the late 1930s they saw nothing but distorted masks, pigs' snouts, and satanic faces. Then as now,

those who were willing to tolerate such imagery did so for the sake of the symbolic message it was thought to contain – Picasso's abhorrence of war and destruction. Another reason for the largely negative response to his work at the time was that very little of it actually reached the public eye. As most people saw only an isolated canvas here and there, they were easily tempted to mistake style for content. Only with the benefit of hindsight, when the artist's pictures of this period finally went on show, did it become possible to realize that distortion is a principle which dominates and permeates Picasso's oeuvre; ultimately, therefore, it neutralizes its own expressive impact.

Study for Guernica 1937

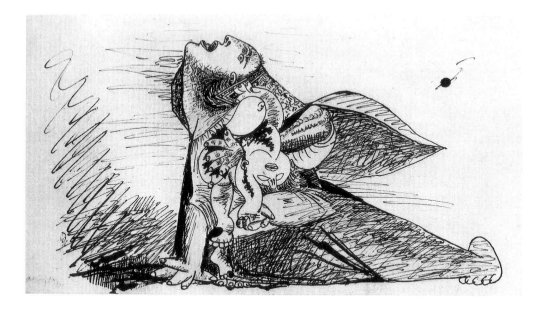

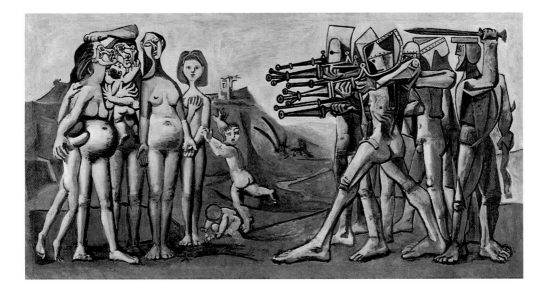

The Limits of Representation

We referred above to a number of pictures made in Royan. In stylistic terms, they were relatively radical, but one should remember that they were all of children who did not belong to Picasso's family. With his own children, he took a quite different approach. This raises a number of questions. What is the relationship between this tender, personal subject and the radical pictorial means Picasso then had at his disposal? It would seem that he found the extremes to which he had taken his style in the 1930s unsuitable for portraying his own offspring. Can one say that he approached this subject like any other, or did he devise a specific strategy for dealing with it? These are questions that have not previously been asked. The problem at issue here is that of the extent to which a given motif is compatible with the intrinsic expressive potential of a particular style.

Picasso's concern with the problem of reconciling theme and style is already indicated by the fact that he initially felt the Cubist idiom to be unsuitable for depictions of children. And, as we have repeatedly seen, he always endowed the picturesque motif of the child with an iconic significance. In other words, Picasso's approach to children says something about his general aesthetic beliefs. And from the manner in which he depicts them we may infer

the value he places on the intrinsic expressive quality of the style chosen for the task. Now that we have looked at a number of works and styles, the importance of this issue can perhaps be fully appreciated.

In his pictures of children, Picasso's avant-garde positions tend to appear in a milder, toned-down form – *con sordino*, as it were. Both the extreme encryption and the extreme dismemberment to which flesh and objects are subjected in Picasso's imagery stop at the door of the children's world. This makes the contrary examples quoted above all the more revealing. Quantitatively speaking, they carry no real weight. They remain isolated experiments, since the results arrived at in these few stylistically extreme depictions of children never crystallized into conventions to be employed for further pictures in this vein. This element of self-restraint distinguishes Picasso's treatment of the motif from that of almost every other theme found in his oeuvre. The tumultuous formal conjugations seen in the faces and bodies in many of the cycles of paintings and sketches are a great deal less radical in the renderings of children. The metastases and biomorphic mutations that deform figures and expressions are absent. One simple reason for this is that Picasso never addressed some of the key variations on the theme.

Adolescence, for instance, was apparently taboo. Lascivious nudes after the manner of Balthus or Bellmer left Picasso cold, and there is no evidence whatever of an interest in Lolita-style eroticism. Instead, it was the nude, adult, female body that inspired him to the point of aesthetic frenzy. Themes with libidinous associations were what he found most challenging. In the process of variation to which Picasso subjected such motifs, they generally underwent a formal transformation leading to a culmination that clearly verged on sheer destruction. At this point, formal variation suddenly took on a new quality, giving way to a kind of purely impulsive aesthetic act, so charged with passion that it can no longer be explained in formal terms. Again and again, the artist drove himself to the verge of overstrain, from the point of view of both form and content. In his *études*, cumulative sequences built of variation upon variation. Picasso was not content merely to capture various aspects of the model. In his hands, variation led beyond the multiple-viewpoint rendering of the motif.

Yet, as we have said, the depictions of children remained largely untouched by variation. Picasso's most far-reaching and

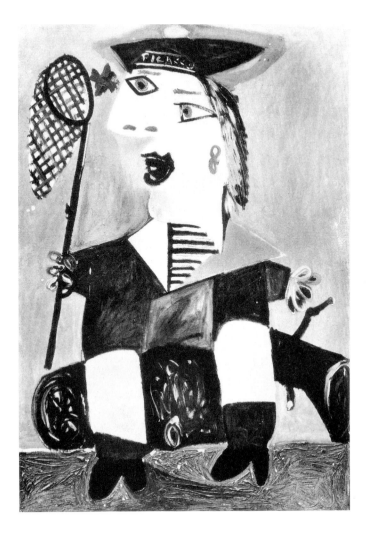

The Butterfly-Catcher 1938

fruitful working technique. His pictures of children were one-off, individual works, and in executing them, he concentrated on portrayal rather than on development. This had considerable consequences for the pictures under discussion. By depicting a child as a recognizable individual, Picasso protected it, so to speak, against his own formal excesses. This is confirmed by the exceptions to the rule: the few cases where, in his sketchbooks, the artist took a child as point of departure for a sequence of variations. These rare examples in which Picasso pursues the same motif continuously, from one sketch to another, underscore the difference in treatment of the theme. Although in one such sequence Picasso presents numerous different versions of his little daughter, Maya,

he never alters or heightens the level of realism decided upon at the beginning – a level of realism which does not breach the convention that pictures of children have to be pretty and charming.

This self-imposed limitation is virtually unique in Picasso's post-Cubist oeuvre. It preserved the children with whom he was personally involved from the radical deformation found in concurrent works. Picasso treated them with consideration and respect. At the same time as he depicted the two strange youngsters, he also drew several portraits of his daughter Maya. These he did in a classical style that brought the little girl's features out with complete clarity. This restraint, dictated by the subject matter itself, is also apparent in the sketches Picasso made in later years of his grandson, Bernard. While in the first drawing he emphasized the newborn infant's typically unappealing facial expression, he refrained from increasing or exaggerating the dissonance in the subsequent variations.

Consciously or unconsciously, Picasso seems to have been subject to a degree of social, moral, and aesthetic control. This brings us back once again to the inhibitions he felt with respect to the depiction of specific, identifiable children, especially his own. It was a motif surrounded by a taboo: formal excesses were largely ruled out. These observations lead us to the following conclusion. It would certainly be going too far to explain Picasso's restraint in terms of a fear of incest. Yet to understand his embarrassment about making radical artistic incursions, we can nevertheless suggest an aesthetic equivalent to the Freudian mechanism and speak of a deformation taboo that took effect whenever Picasso addressed the subject of children. If this is taken to be true, it lends the paintings on this theme a highly significant role within the oeuvre. Because of their special content, they put a check on the formal iconoclasm that was a key part of Picasso's artistic personality. The children he depicted with such touching seriousness served as a kind of superego, disciplining the wilder side of his nature. In the wonderful image of the blind Minotaur, allowing himself to be led by a child (p. 68), Picasso exorcised his inner demons in an unforgettably moving way.

The Artist's Daughter 1943

Right:
Child in a Chair 1939

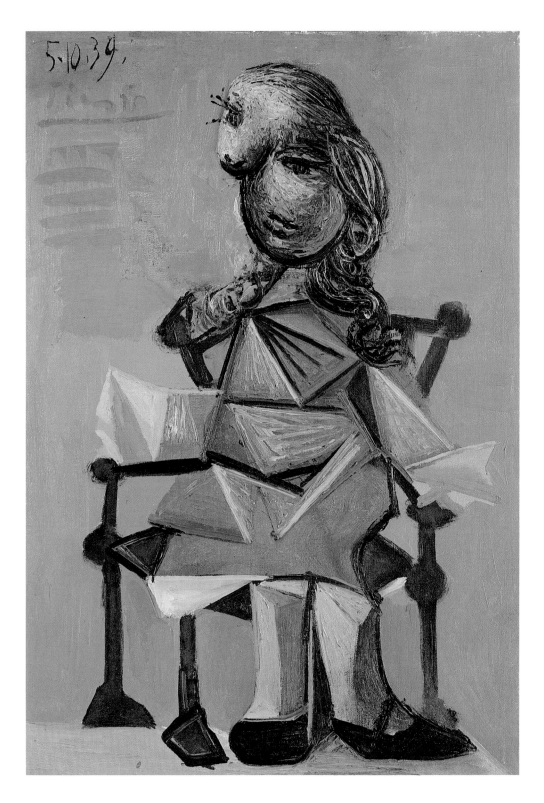

79

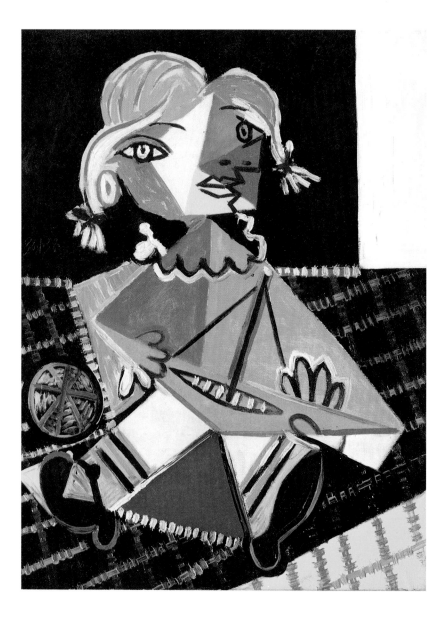

The Artist's Daughter with a Boat 1938

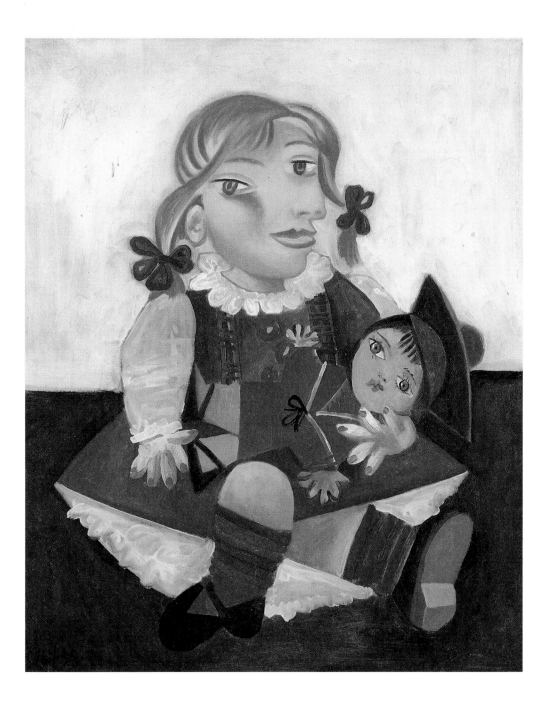

Maya with a Doll 1938

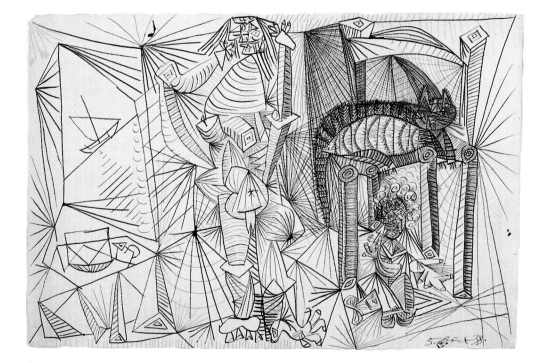

Woman, Cat on the Chair, and Child under the Chair 1938

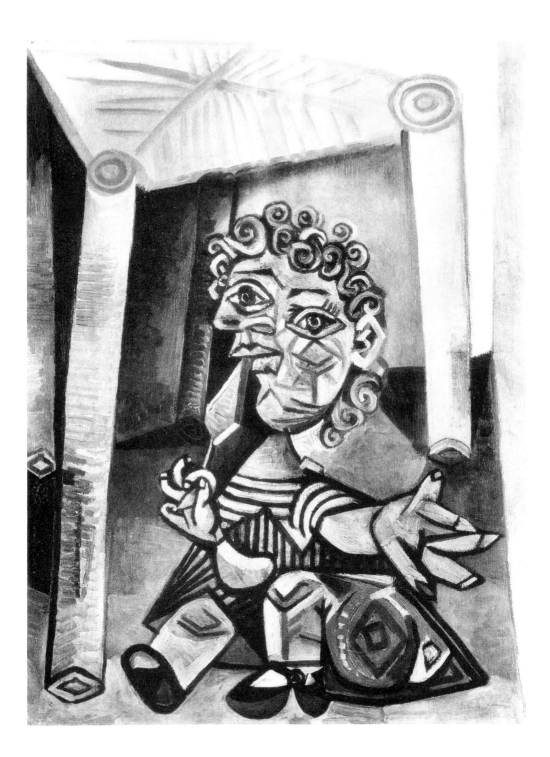

Child with Pacifier under a Chair 1938

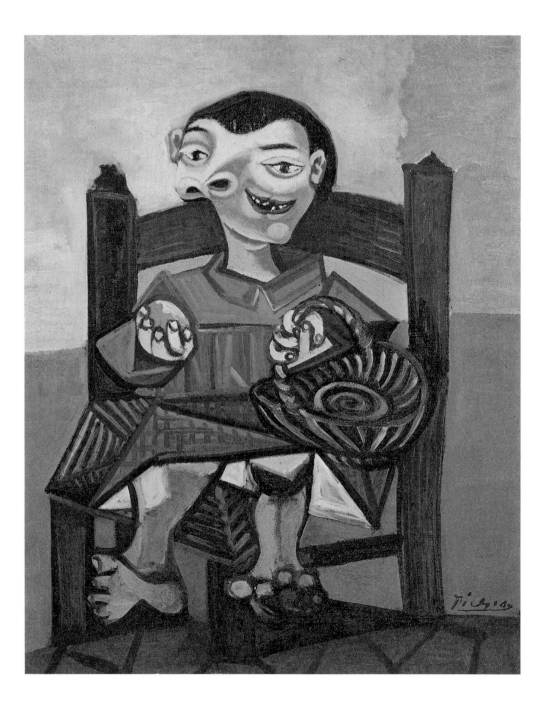

Seated Child 1939

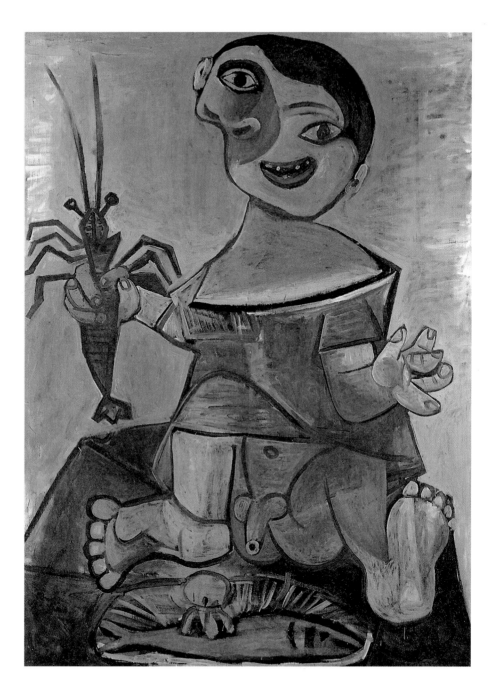

Boy with Lobster 1941

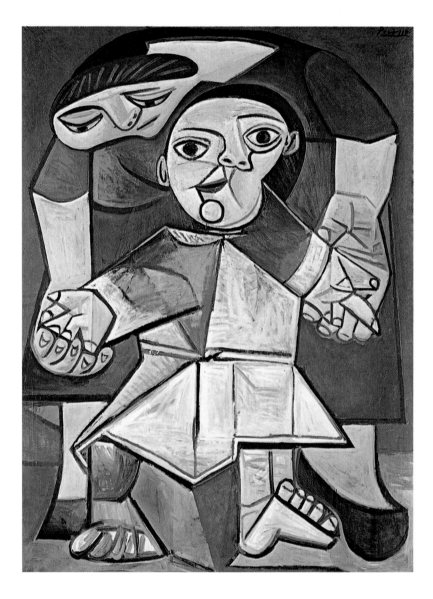

First Steps 1943

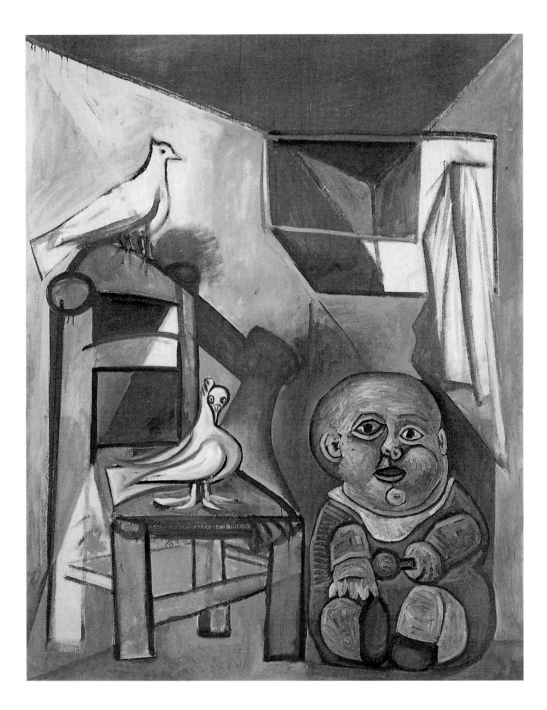

Child with Doves 1943

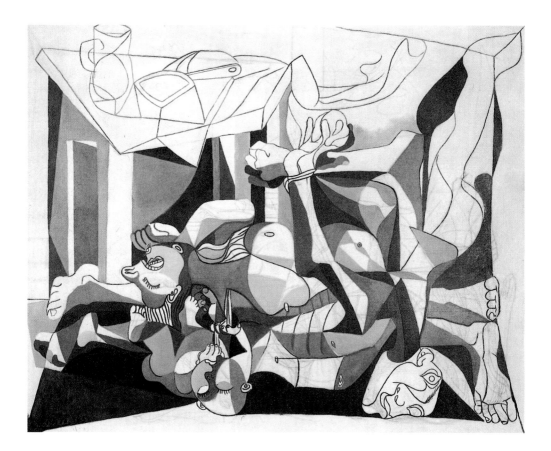

The Charnel House 1945

Right: The Rape of the Sabine Women 1963

88

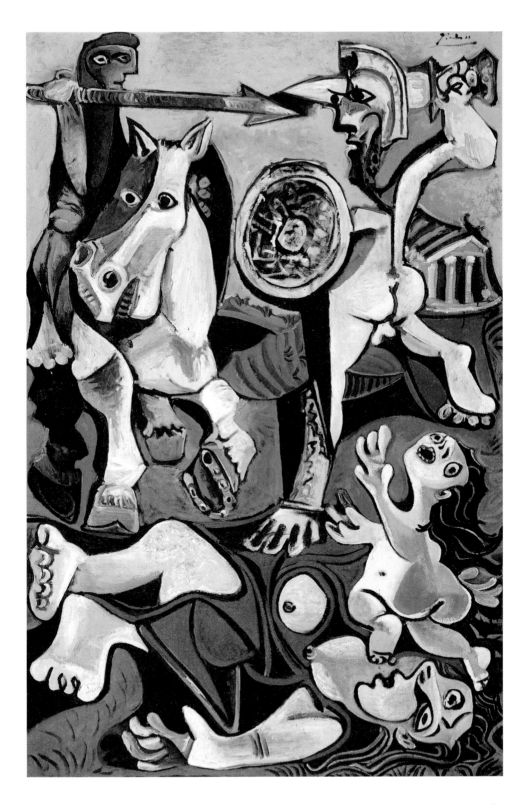

"First Steps"

The many drawings and paintings devoted to little Maya show an obvious change in mood. Stylization is reduced in favor of a plethora of details reflecting childish behavior, and a steadily growing interest in children's physical characteristics and gestures. The change is recorded in Picasso's writings, for example, in the telling phrases used to describe Maya in late 1935 and early 1936: "The tears of a little girl-seashell," and "the cradle of astonished eyes."[29] Such precise and poetic observation transformed the artist's treatment of the motif, which now began to include narrative elements, and displayed a new exploratory precision. A case in point is the drawing *Little Girl with Nanny*. Whereas the children of the Blue and Rose Periods were often only adjuncts of an adult world, and Paolo's appearance conformed to the expectations of his bourgeois family, Picasso's children now began to exhibit the gestures and ideas of children caught unawares, with no idea that they are being observed. In other words, the artist entered into their inner lives, their specific way of thinking and acting. Consequently, his pictures entirely lost the ingratiating genre touch that evokes an idyllic state: the neoclassical family scenes and depictions of children decked out in mythological costume, so prevalent since the 1920s, became a thing of the past. Again, the change might be described in Picasso's own words, which can stand as a poetic commentary on his work of the late 1930s: "The teeth covered with orange down, musing in the gums of the child's sailor suit, as it kneels on the back of the table burning along the pages."[30] Such statements abound in the artist's writings of this period.

Picasso's increased expressive precision was accompanied by an often wild and self-fueling proliferation of forms, which took on an untamed, almost savage character. In this respect, too, Picasso's writings provide revealing insights into his work of the late 1930s and early 1940s, references that so far have been largely overlooked. Many of his striking formulations seem to demonize the world of children, to destroy its charm and the aura of happiness that surrounds it. In his second stage play, *Les quatre petites filles* (The Four Little Girls), a certain cult of cruelty even manifests itself. One of the four girls suggests a game to the others, saying, "Let us open all the roses with our fingernails and let their perfume bleed onto the folds of fire of our games and songs and our

Claude, Aged Two, in His Little Car 1949

yellow. blue. and magenta aprons. Let us play until we hurt each other. and embrace each other with rage and terrible screams."[31] This call to throw harmony aside doubtless reflects Picasso's own determination to charge his style with all the harshness and dissonance exhibited here. The paradoxes of the child's world come to the fore; Picasso's young. graceful figures are seen to be bursting with merciless and often cruel vitality.

From this point on. the view of childhood in Picasso's art becomes increasingly contemporary. Instead of being members of a private retinue. governed by a rigid decorum that turned his earlier versions of the theme into frozen. if charming. icons of childhood. his children now began to act in a way more reminiscent of a Montessori kindergarten or a "progressive" school. Late echoes of this are even apparent in the variations on *Las Meninas* (pp. 114 - 15) done in the late 1950s. at a time when Picasso's own children were no longer continually around him. His "moderni-

Motherhood
(Vert-Galant Park) 1944

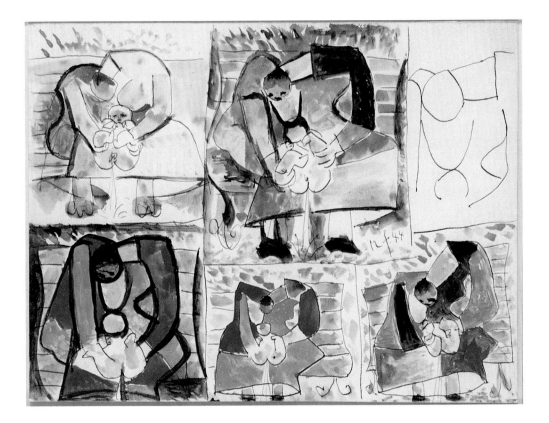

zation" of the Infanta went so far that in one of the final paraphrases of the series she appears as a contemporary little girl playing the piano. Not a trace of drill or training in "good" behavior is found in the pictures of this period, which often show Claude and Paloma crawling around the floor on all fours. An antiauthoritarian atmosphere pervades the paintings that Picasso devoted to his youngest children. The depictions are more dynamic: the objects and toys included, as well as the pictorial means used, all point to a change of attitude. This is partly due to biographical circumstances. Instead of the family's everyday life, these pictures record only exceptional moments of happiness – Picasso's children had begun to spend only vacations and holidays with him, and even this arrangement was soon to be rescinded.

The compositions in which mother and children appear together are revealing in the way they define the children's realm. References to deep emotional ties or a close relationship are missing. Picasso shows us two separate worlds. Something of the loneliness that mutually isolates adults and children pervades *In Front*

Les déjeuners 1961
Bathers 1961
Les déjeuners 1961
Les déjeuners 1961

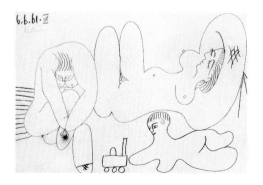
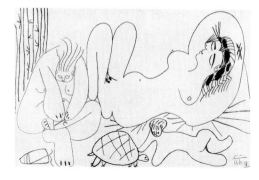
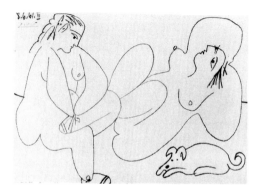
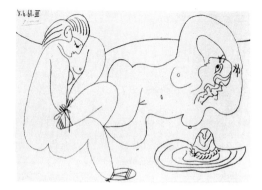

*Paloma and Her Doll
on Black Background 1952*

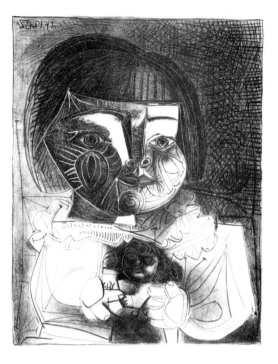

of the Garden (p. 105). a painting done in Vallauris in December 1953. It is one of the very few exceptions to the rule that Picasso avoided depicting himself as part of the family. Yet even here. he does no more than hint at his own presence. In the background we see Claude playing with a toy car. and in the foreground. the phantom silhouette of the artist. with pencil in hand. The sense of alienation felt here might best be described by reference to Runge. whose depictions of children "prepare us for that urgent and complete immersion in the guarded. private secrets of the children's unique world."[32]

These unforced. yet precise images – images of independence – did not appear overnight. As we have seen. they were prefigured by a series of vivacious and natural portraits of Maya. which were supplemented in the early 1940s by a few paintings and sketches focusing on childish activity and behavior. These works are examples of the "child as motif" genre: they feature small children. aged between one and two. who were not part of Picasso's own family circle.

With *First Steps* (p. 86). Picasso entered the child's world in a new way. As the title indicates. what interested Picasso here was

Drawing done jointly by Picasso,
Paloma and Claude 1953

that strange and astonishing moment of motor activity when a child first finds its feet. The challenge lay in the extreme torsion of the little body, which is wonderfully well-observed. Here, as later, when Picasso drew and painted Claude and Paloma, a small child's movements lead to a number of innovative stylistic distortions. Yet these are still grounded in reality: Picasso accentuates the sense of *verismo* by emphasizing characteristic details. In the numerous depictions of Claude and Paloma in their baby carriage or bed, or at play, the natural proportions of the child's figure remain largely intact. Granted, the volume of a head is occasionally exaggerated, or hands and feet are emphasized like capital letters. Yet this, I believe, only goes to support my contention that Picasso never employed distortion in a negative sense when painting or drawing children. These distortions had nothing to do with

caricature or monstrosity, as critics of the 1950s maintained: "This pleasure in the monstrous will have become so familiar to him that he probably does not even feel tempted to dispense with it in the portraits of his children."[33]

Nowhere in these pictures does Picasso's heightened vision contradict actual observation. On the contrary, everything seems highly plausible. The emphases merely serve to extend the range of precise statements made here about children and their nature. The youngsters have a padded look about them, and there is nothing harsh or angular in the things around them: rolls of puppy-fat soften the hard contours. These exaggerations of form and movement reflect the typical proportions of childish anatomy. The emphasis is not on the cute or pretty, but on the uniquely childlike. This tendency is apparent from the outset in the first pictures devoted to the precise observation of children's bodies, such as *Child with Doves* (p. 87). And it grew continually more marked in the numerous depictions of Claude and Paloma's childish activities. For all the stylistic liberties Picasso took with the two children, he still retained their portrait likeness. He concentrated, for example, on their round, open faces, in Paloma's case heightening the effect by an emphasis on the pageboy haircut that frames her face. The motif preoccupied Picasso in a great number of paintings, drawings and prints; as Françoise Gilot

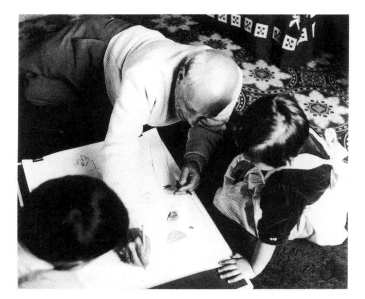

Picasso drawing with
Paloma and Claude 1953

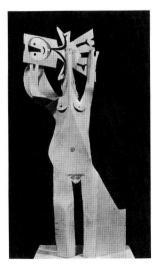

Woman and Child 1961

recorded, he spent "hours" drawing and painting his offspring.[34] The childish, round faces are frequently echoed by the wheels of a baby carriage, a visual rhyme that links the figures with their environment and lends the compositions a greater complexity. Often Claude und Paloma appear together, creating a contrast in terms of age difference that supplements Picasso's attempts to underscore the distinct characters of the little girl and her older brother.

When speaking of his accentuated delineation of children's figures, we should add that the way in which Picasso captured childish behavior and empathized with children's psychology was invariably in harmony with what I have described as his attempt to enter children's inner lives. The presentation of what he found there was to become the great pictorial subject of this period.

Objets Trouvés and Toys

In the course of his long career, Picasso had developed a number of techniques to cope with the opposition between reality and autonomous form. He must therefore have felt challenged by the opportunity to empathize with an unfamiliar mode of perception – that of children. This implied investigating the way in which children see the world, rather than producing art in a childlike vein. For unlike Klee, Picasso rarely concerned himself with the direct imitation of childish drawing and painting. Apart from the occasional sudden abbreviation of motifs to simple contours or graphic symbols, Picasso's work displays almost no sign of a direct influence of children's art. For example, the naive symbols children use to represent heads or hands rarely echo in his imagery. The reduced forms he employs generally represent the final stage of his involvement with a motif, in a process of abstraction that led from complexity to simplicity. This is not really surprising, given that a direct adoption of existing forms is not found even in those cases where Picasso turned his attention to non-European art – that other unfamiliar mode of cultural perception. Instead of reproducing the look of an African sculpture, he would endeavor to discover the underlying principle of its design. The same is true of these scenes with children. Picasso entered into the minds of children engaged in discovering their environ-

Baboon and Young 1952

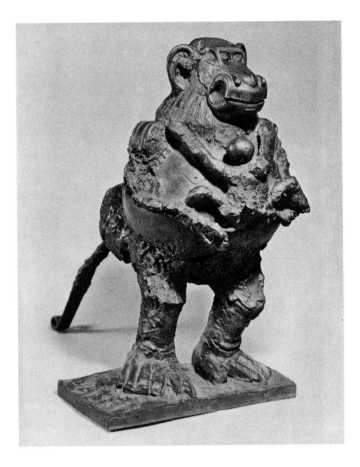

Toy cars:
a Panhard and a Renault

ment. An indication of this is his emphasis on haptic behavior, evoked by the outsized hands and feet. These children appropriate things with instinctive greed, pushing aside everything that stands in their way. It is a far cry from the situation of children in Picasso's earlier work, who were unable to take possession of their environment and the things it contained. Their grasping hands usually turned up empty.

We cannot be content merely to enumerate these astonishingly veristic traits in the paintings of the period, for they are works that shed a great deal of light on Picasso's artistic idiom. What they reveal is a virtual copying, an instrumental adoption, of childish behavior in general, and childlike spontaneity in particular. Here, Picasso's main concern is not with the motif, but with the child as model for an aesthetic strategy. At the same time as he was producing these free and empathetic depictions, Picasso was involved in expanding the range of his own marvelous artistic

97

games. He grew ever more interested in the possibilities offered by objets trouvés, and many of the things he employed were borrowed from the world of children. He carved and painted dolls for Paloma, just as – years before – he had made dolls and marionettes for Maya. He cut out and painted figurines, and even made an entire puppet theater. There are many photographs that record how Picasso played with his children, drew and painted with them, and joined in their masquerades (pp. 94-95).

Still, a closer look at his participation in the children's world indicates certain flaws in the relationship. There is no evidence of a naive identification of the artist with the child. Instead, much of Picasso's imagery tends to suggest a nostalgic yearning for a lost paradise. This is corroborated by several passages in his writings. In the *Album de Françoise*, under the heading "Vallauris, Thursday, June 7, 1951," he noted: "People are outside in the sun. I hear Paloma's tears in the garden. I see the tips of my feet stretched out on the bed, and, at a distance, the fireplace, the little radio, the books, magazines, letters, Rousseau's portraits of his wife and himself at twenty past four in the afternoon." This description is accompanied by a drawing that records the artist's gaze, from the depths of his own consciousness, into a remote and separate world. We see a foot, the bed, the radio, and the portraits over the fireplace. The way in which subjective perception and surroundings relate to one another here recalls the sketch used by Ernst Mach, in *Analysis of Sensations*, to illustrate the notion of the "irrecoverable" self. Picasso's domestic idyll was often suddenly disrupted by such feelings of relativity and alienation. Again and again, life penetrated into his world from outside, invading the quiet of his studio. He recorded these sensations with great precision: "Paloma's very gentle voice and the sound of wooden toys on the sand, the way it rubs against the wheels, a scream – whose? – that rips the stretched canvas of the picture of her that same day at quarter past ten at night – for whom?"[35]

Picasso played with his children, but he also confiscated the toys they had received as gifts, using them to produce unexpected metamorphoses. Two toy cars that Kahnweiler had given to Claude – a Renault and a Panhard – were transformed into the head of the famous sculpture *Baboon and Young* (p. 97). The roof of the Panhard became the baboon's forehead, with eyes inserted in the windshield; the hood became its muzzle, and the grille evoked the rough fur under the nose. The second car was rotated

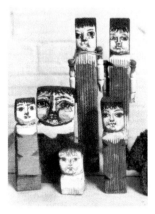

Paloma's dolls ca. 1953

Right:
Woman Drawing with Her Children
1950

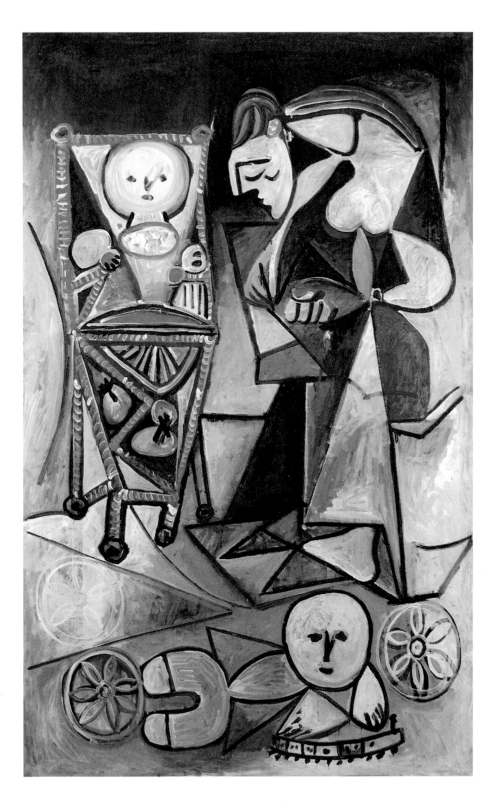

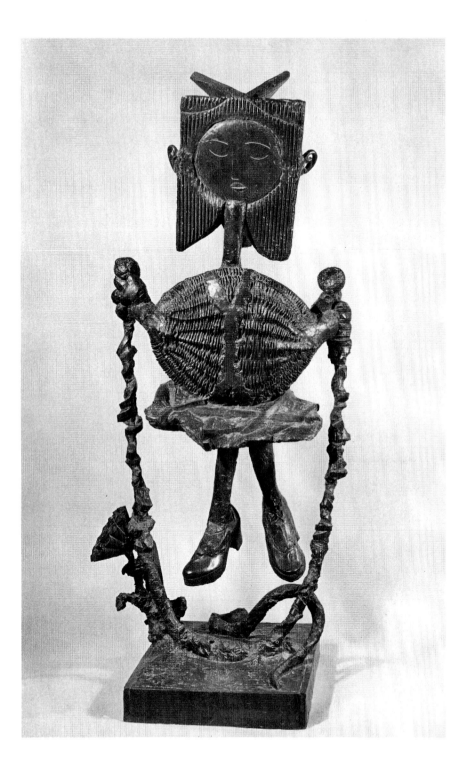

Girl Skipping Rope 1950

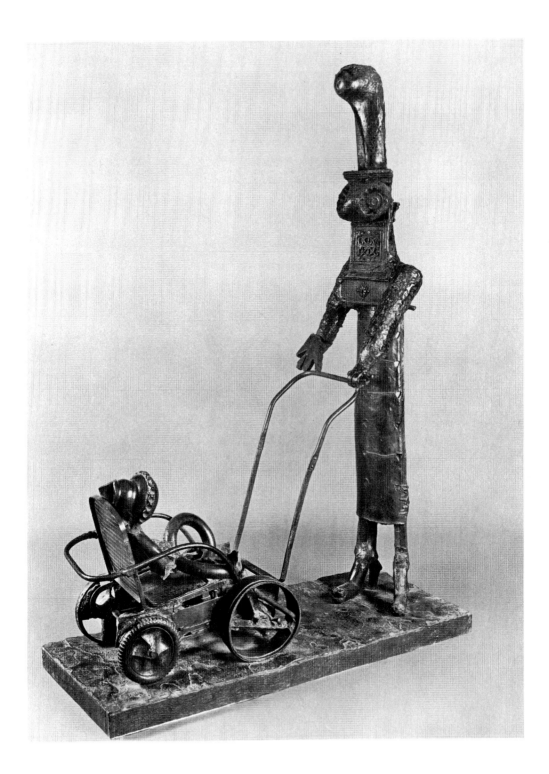

Woman with Baby Carriage 1950

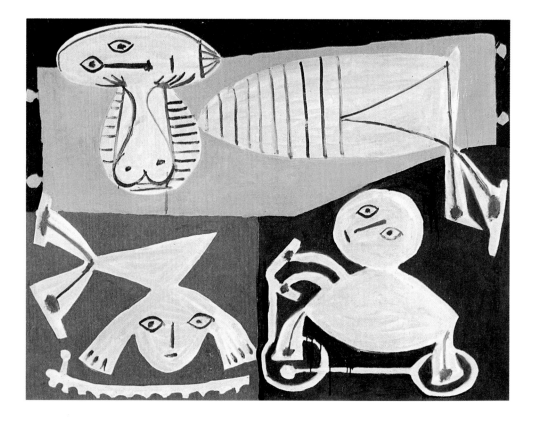

Françoise Gilot with Her Daughter Paloma and Son Claude 1951

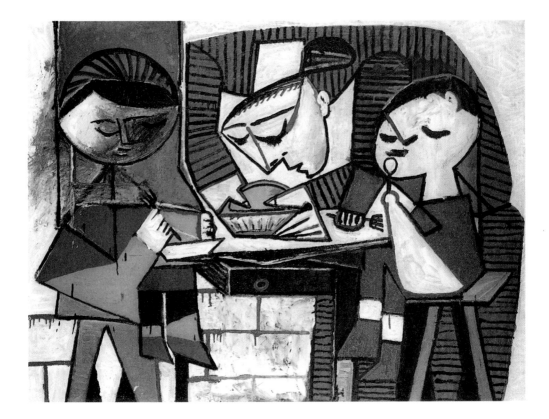

The Children's Mealtime 1953

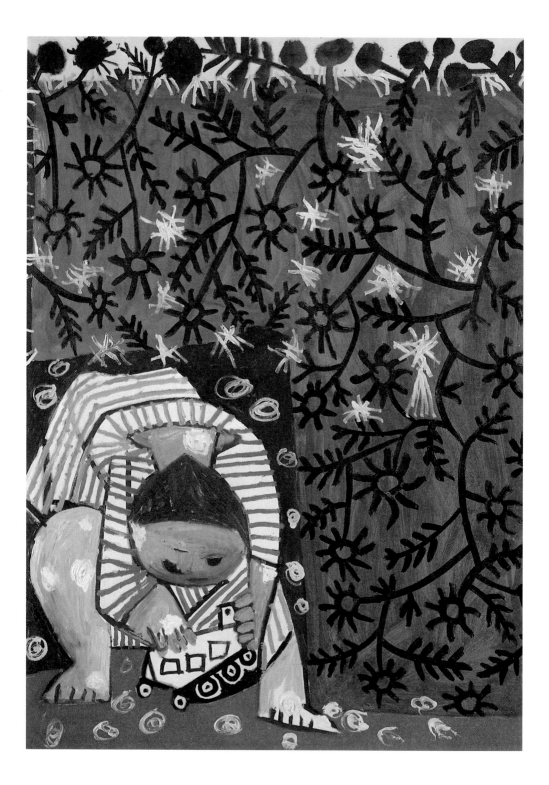

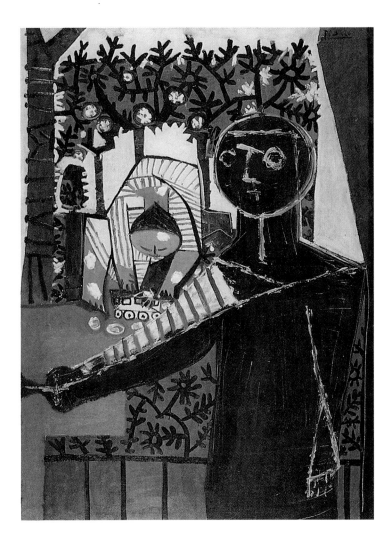

In Front of the Garden 1953

Left: Child Playing with a Toy Truck 1953

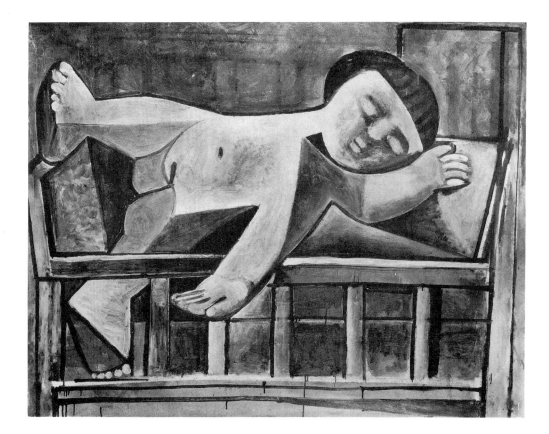

Paloma Asleep 1952

180 degrees and mounted under the first, with the gap between them forming the mouth. This is only one example of Picasso's re-christening of commonplace objects.

His work in sculpture increasingly focused on objets trouvés, in a process of playful construction that finally culminated in the large-scale "encyclopedic" sculptures made in Vallauris. It is no coincidence that several of these had to do with family and children: *Woman with Baby Carriage* and *Girl Skipping Rope* (p. 100), to name only two. In these pieces the adoption of a child's viewpoint results in a unique type of dual perspective, involving the child's perception of its surroundings which first appears in *Child with Doves* (p. 87). Picasso shows us children in a real environment, yet this setting remains related to the children – it is seen in proportion to them. This is what makes his pictures of Claude and Paloma so compellingly effective. *Girl Skipping Rope* contains a number of details in which childlike qualities are unforgettably embodied. To convey the girl's awkwardness, for instance, Picasso gives her two huge shoes – on the wrong feet – which together with the flying skirt and carefully combed and be-ribboned Sunday hairdo lend the lifesize sculpture a delightful note of realism.

In *Woman with Baby Carriage*, too, the artist relies on only a very few, telling details to characterize mother and child. Little Paloma's figure is formed with the aid of descriptive elements chosen from the abundance of objects that had accumulated in the artist's studio. To evoke the baby's restlessness, Picasso took the handles of an amphora and transformed them into an infant's kicking bowlegs. The lacy border of the sun-bonnet encircling the little face emphasizes the carefree nature of the motif, which contrasts sharply with the austere, towering verticality of the mother's pose.

Entering the Child's Perspective

The dual perspective encountered in these works can also serve as a general model for artistic vision. Gertrude Stein pointed this out in the book she wrote on Picasso in the late 1930s. The paradigm of childlike vision, side by side with the symbolism of African sculpture, provides an insight into the conceptual approach adopted by Picasso in the development of Cubism. Gertrude Stein detected the origin of his vision in the fragmentary semantic perception of the small child: "A child sees the face of its mother, it sees it in a completely different way than other people see it. I am not speaking of the spirit of the mother but of the features and the whole face, the child sees it from very near, it is a large face for the eyes of a small one, it is certain the child for a little while only sees a part of the face of its mother, it knows only one feature and not another, one side and not the other, and in his way Picasso knows faces as a child knows them and the head and the body."[30]

Claude, Aged Two 1949

This visual knowledge of others' bodies, and the ability to see through their eyes, manifested itself in the series of works for which Marie-Thérèse Walter posed in the late 1920s and early 1930s. Many of these reveal an emotional, possessive vision that seems equally informed by Picasso's erotic desire for Marie-Thérèse and her own attraction to him. This is especially apparent in the sculptures of the Boisgeloup period, with their swelling volumes distorted as if under the influence of a passionate encounter. The privilege of intimacy is expressed here, a vision of the other at the moment before a kiss. Seen at such close quarters, forehead, nose, cheeks, and head grow to enormous proportions, as if viewed through a magnifying glass. And one senses how the artist's greedy eye literally gropes its way from one feature to the next.

Gertrude Stein's explanation of Picasso's technique in terms of a young child's perception is corroborated by many passages in Picasso's own writings. They indicate the very concrete nature of his involvement with the subject of childlike vision and behavior. On September 16, 1941, in a remarkable text inspired by an attempt to enter completely into a child's mind, Picasso noted: "At quarter to four sharp in the blazing sun, I.'s child and the other one leaned out of the window and played with their fingernails and their flecks of light and shade to the trumpet music ... the mother, five feet eight, two arms, two legs, two hands, two feet, a

head, two eyes, two ears, a nose, a mouth, a belly, hair, intestines, two breasts, a navel, a butt, a cunt, twenty fingers, hair on her legs ... its mother, its mommy, watched I.'s child and the other one, cuddled it, gave it her soup to drink from her breasts, washed it mornings and nights, combed its hair, sewed clothes for it to wear, went to the movies with it, to the theater, to the beach, and slapped it, mommy, mommy, I'm finished, mommy, give me something to drink, mommy, I'm thirsty, mommy, I'm hungry, mommy, I'm tired, do you want me to wipe your nose, are you warm, are you cold, coochy-coo, do little-little, big-big."[37]

Of the various aspects of the text that refer to the child's vantage point on the world which Picasso attempted to realize in his pictures of children, one above all deserves attention in the present context. This is the enumeration of the building blocks of which, in a child's eyes, its mother consists. The survey of her body, the addition of various parts and functions to form a whole.

Paloma with a Toy Fish 1950

is expressed in a language based on childlike patterns of thinking. Its structure is analytical, recalling that of nursery rhymes. This cumulative procedure occurs repeatedly in the notes Picasso began to make in April 1935. Writing in a largely paratactical style, he set one thing next to another, following a random trail of observations. Over the ensuing years, this way of seeing the world evolved into one of Picasso's key working strategies.

The Cubist approach, in which things were continually rotated and viewed from different vantage points, and which saw its purpose in fragmenting objects rather than rendering them as a sensually coherent totality, finds an analogy in Picasso's later texts. Their linguistic dissociation is achieved by means different from those of Surrealist *écriture automatique*. It would appear to be the result of a systematic linguistic critique in which fixed structure is replaced by provisional form, and syntax is disrupted in such a way that subject-predicate-object relationships no longer indicate a single direction of reading. The texts can be read diagonally, as well as from left to right. Moreover, the abbreviated syntax and the redundancy of the linguistic material cause the reader to jump back and forth between terms, continually seeing new phrases and sentences. This flexible quality is further enhanced by the lack of punctuation. Another striking feature is the repetitions, presented with a relentless, exhausting energy, allowing certain phrases to crop up again and again, with only slight modifications. Indeed, repetition is the main device: one's impression is of the continual writing and rewriting of a set text, recalling the learning processes of children or the lines assigned by a teacher to an unruly pupil.

Nevertheless, in the course of this incessant reiteration, significant changes occur. Words repeated over and over again lose their meaning; they become ambiguous and strange. Yet they also take on a new interest, challenging the author to play with them and create ever-new combinations. Picasso's way of dealing with language bears a fascinating similarity to his treatment of visual form. His linguistic games can justifiably be seen as a model for his approach to painting and the games he also plays with the imagination of the child. During these years, Picasso's involvement with the painting of the past grew ever deeper, as he turned to the museum as a source of material for his ludic visual sense. It is as if he had deliberately set himself the task of producing one variation after another, in a continual effort of paraphrase.

A page from the notebook
Dibujos y escritos
(p. IX. January 9. 1959)

Late Works

How is the subject of children treated in the final phase of Picasso's oeuvre? Among the children whose names are known we find – in the series *Woman and Little Girls* from 1960 and 1961 – Cathy, the daughter of Jacqueline. Picasso also devoted a drawing to her, inscribed with the words "Pour ma fille de lait" (For my nursling girl). In these pictures, which followed upon the variations on Velázquez's *Las Meninas*, the child gradually reverts to what it had been at the outset: a symbol. The contrast between child and old man is alluded to only very indirectly, and the mood of resigned tenderness that characteristically accompanies this well-known theme is entirely missing. Nor is the traditional subject of the "ages of man" treated in these works.

An immediately striking feature of the last paintings, in which Picasso increasingly sublimated the physical impotence of an old man in fantasies of sexual dalliance, is the complete absence of children. They were not allowed to watch the final episode; only the occasional putto is permitted to be a spectator. These cherubic figures are seen as mocking little angels, challenging the lovers to go on to the bitter end. They were the last messengers from the youthful, heathen world of Mantegna's *Camera degli Sposi* to reach the studio at Mougins. In the very last paintings where this motif appears, a sense of tristesse coincides with an illusion of eternal youth. Yet neither here, nor elsewhere in Picasso's oeuvre,

is any trace of a dubiously equivocal erotic atmosphere to be found. There is no playing with dolls in the manner of Kokoschka or Bellmer.

"Basically, there are only a few subjects. Everybody repeats them. Venus and Cupid become the Virgin with Child, the classical image of mother and child – but as a subject, it's the same." This statement, reported by Kahnweiler,[38] has a fatalistic ring, as if subject matter held no interest for Picasso at all. At any rate, it goes a long way toward explaining his restraint with regard to motifs. Surprisingly, though, it was precisely in his treatment of subjects which "everybody repeats" that Picasso proved to be a radical and revolutionary reformer of content as well as form. What he sought was not so much the cohesive and comprehensive solitary image as a depiction of potential forms into which a small number of elements could enter. Seen in this light, Picasso's reference to repetition takes on a key significance. It supplies a reason for his self-imposed limitation to a very few subjects. This, in turn, permitted the extraordinary heightening of form and the extreme close-up vantage point in his depictions of the child's universe.

Picasso's approach to the subject of the child obviously changed over the course of the almost eighty years in which he occupied himself with it. Apart from his personal stylistic development, the changes reflected the social, political, and educational situation of the times. Several decades lay between the spiritualized children of the Blue Period, the 1920s cults of the Madonna and of a heathen, Mediterranean fertility, and the final vision of liberated children existing in their own specific world that so obviously dominated Picasso's work of the 1950s. Still, it would seem impossible to define the expressive aspect of the children in these pictures in a precise, illustrative sense, or to recount the stories they tell. Too many aesthetic metamorphoses and reflections interpose themselves between a psychological reading and an abstract formal message. We have repeatedly mentioned the extent to which, right from the outset, the meanings of Picasso's imagery retreated behind body language and style. The taboo he imposed upon himself prevented him from applying his style at its highest – or most extreme – level to the subject of children. He addressed this grand and inexhaustible theme in the manner of a child playing a game of hide and seek.

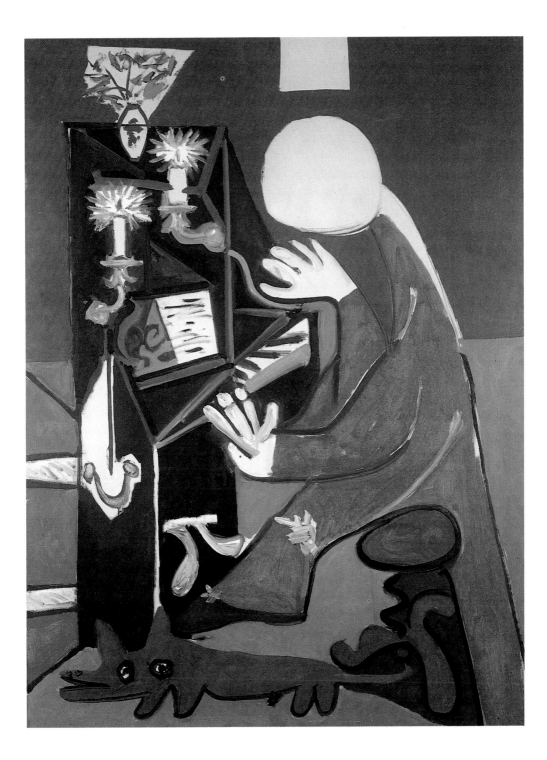

The Piano 1957

Les Meninas. The Infanta Margarita María 1957

Right: Les Meninas. Dona Isabel de Velasco,
the Dwarf, the Child, and the Dog. No. 42 1957

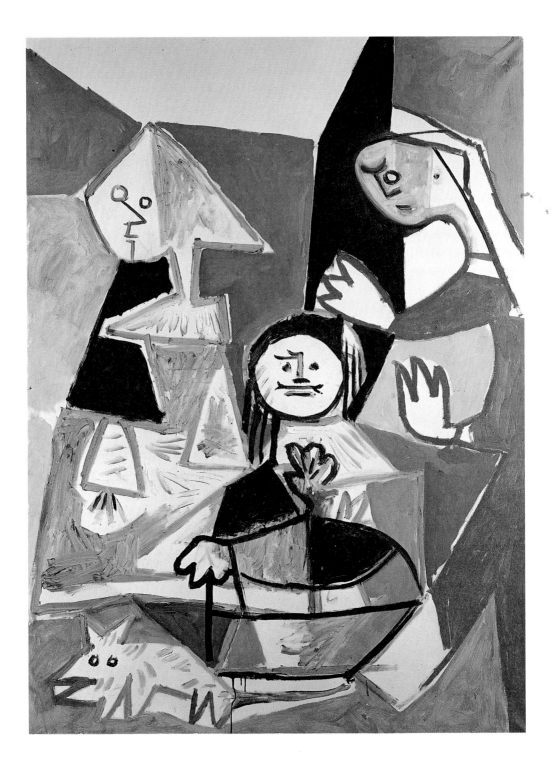

Musketeer with Amor 1969

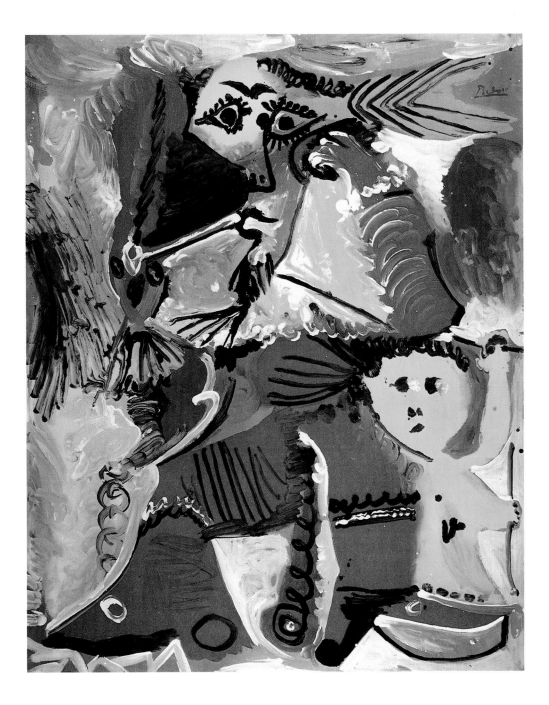

Rembrandt Figure with Amor 1969

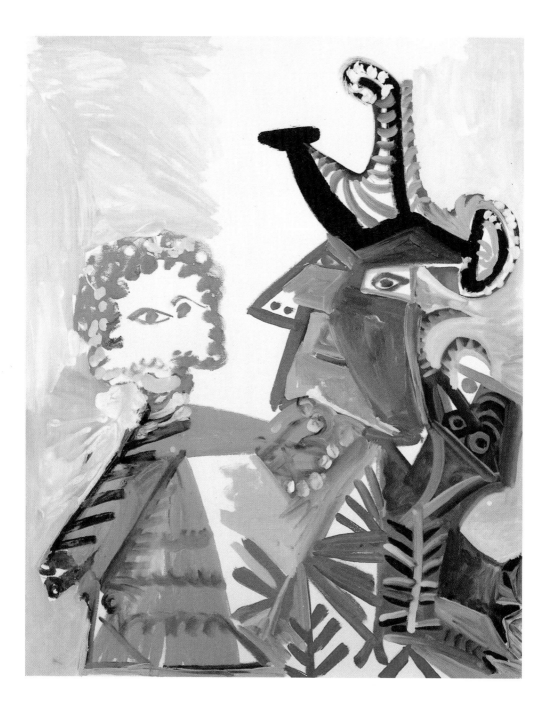

Musketeer and Child 1972

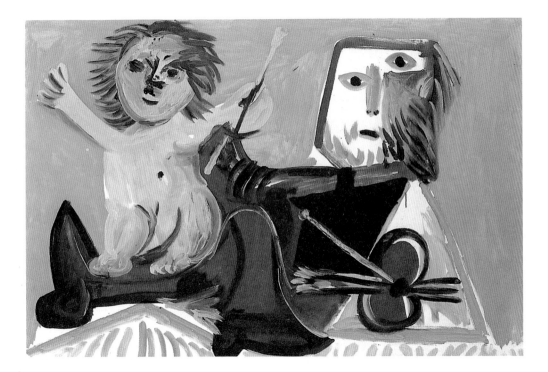

The Painter and the Child 1969

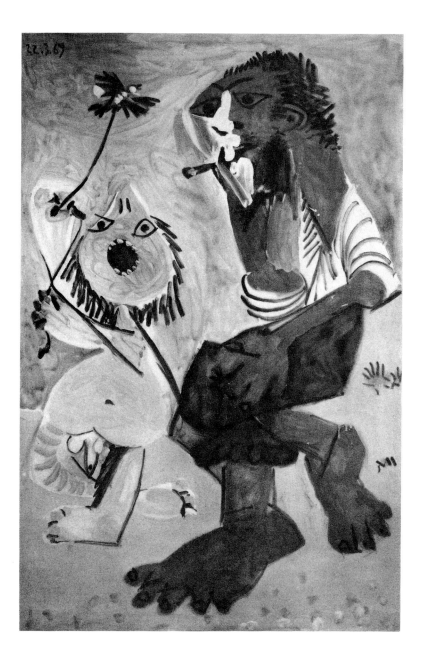

Man und Child with Bird 1969

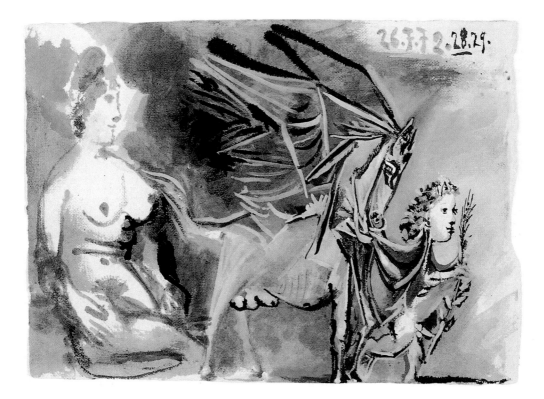

Winged Horse, Led by a Child Holding a Branch 1972

Notes

1 Picasso. April 18. 1935. Quoted in *Picasso Ecrits*. ed. Marie-Laure Bernadac and Christine Pilot. with an introduction by Michel Leiris (Paris. 1989). p. 1.

2 Apart from pictures of children who were especially close to him. and who. like Catherine Hutin. Jacqueline's daughter. belonged to the household (and apart from the daughter of Piero and Landa Crommelynck). children's portraits vanished from Picasso's oeuvre in the final decades of his life.

3 See Jörg Traeger. *Philipp Otto Runge. Die Hülsenbeckschen Kinder. Von der Reflexion des Naiven im Kunstwerk der Romantik* (Frankfurt am Main. 1987). and Robert Rosenblum. *The Romantic Child. From Runge to Sendak* (London. 1988).

4 George Boas. *The Cult of Childhood*. Studies of the Warburg Institute. ed. E. H. Gombrich. 29 (London. 1966). p. 8.

5 André Breton. *Le Surréalisme et la peinture* (Paris. 1928). unpaginated [p. 9].

6 See Tilman Osterwold. *Paul Klee. Ein Kind träumt sich* (Stuttgart. 1979).

7 Giovanni Francesco Caroto. *Fanciullo con pupazzetto*. Museo di Castelvecchio. Verona.

8 Brassaï. *Gespräche mit Picasso* (Reinbek bei Hamburg. 1966). p. 70.

9 Quoted in Josep Palau i Fabre. *Picasso – Kindheit und Jugend eines Genies, 1881-1907* (Munich. 1981). p. 135.

10 In *Carnet catalan* (1906): quoted in *Picasso Ecrits*. op. cit.. p. 371.

11 Félicien Fagus in *Gazette d'Art* (Paris. 1901): repr. in *Cahiers d'Art*. no. 3-5 (Paris. 1932). p. 96.

12 Philippe Ariès. *Centuries of Childhood* (London. 1979).

13 After exhibiting this canvas at the 1900 Paris World Fair. Picasso painted over the image. replacing it with another motif relating to life and death. *La Vie* (Cleveland Museum of Art). The mother holding the child forms a strong contrast to the melancholy lovers.

14 See Antje Gerlach. "Die verlassenen Kinder der armen Leute." in *Die gesellschaftliche Wirklichkeit der Kinder in der bildenden Kunst*. Neue Gesellschaft für Bildende Kunst and Staatliche Kunsthalle Berlin (Berlin. 1979). p. 205.

15 Adrien Farge. "Préface au catalogue de la deuxième exposition à Paris de l'œuvre de Picasso à la Galerie B. Weill. du 1er au 15 avril 1902": repr. in *Cahiers d'Art*. no. 3-5 (Paris. 1932). p. 96.

16 See Werner Spies. *Picasso. Das plastische Werk* (Stuttgart. 1983). p. 66.

17 Rainer Maria Rilke. *Duineser Elegien*. in *Sämtliche Werke* (Frankfurt am Main. 1955). p. 703.

18 Ronald Johnson. "Picasso's Parisian Family and the 'Saltimbanques'." in *Arts Magazine* 51. no. 5 (January 1977). pp. 90-96.

19 Rilke. *Duineser Elegien*. op. cit.. p. 701.

20 Daniel-Henry Kahnweiler. *Meine Maler – meine Galerien* (Cologne. 1961). p. 701.

21 Jaime Sabartés. *Picasso. Gespräche und Erinnerungen* (Zürich. 1956). p. 77.

22 *Bambina che corre sul balcone*. Galleria Civica d'Arte Moderna. Milan.

23 See Hélène Seckel. in *Picasso – une nouvelle dation* (Paris. 1990). p. 24.

24 Montrouge. 1918. Zervos III. 122.

25 On the influence of his collaboration with the Russian Ballet in helping Picasso decide to abandon a unified style. see Werner Spies. "Parade – das antinomische Lehrstück. Picassos Beschäftigung mit Achille Vianellis *Scene popolari di Napoli*". *Kontinent Picasso* (Munich. 1988). pp. 31-43.

26 Georges Hugnet. *Pleins et déliés* (Paris. 1972). p. 177. I am grateful to Hélène Seckel for this reference.

27 A pencil sketch from the late 1930s might be given as a further example. But this was intended as more of a caricature. representing Picasso and Marie-Thérèse Walter surrounded by eight children. Not in Zervos. See *Une collection Picasso. Œuvres de 1937-1946* (exh. cat.). Galerie Jan Krugier (Geneva. 1973). fig. 115.

28 Werner Spies. *Der Radierzyklus Traum und Lüge Francos* (Frankfurt am Main. 1968): repr. in Spies. *Kontinent Picasso*. op. cit.. pp. 45-61.

29 In *Picasso Ecrits*. op. cit.. p. XXI.

30 Entry for March 19. 1938. *Picasso Ecrits*. op. cit.. p. 189.

31 *Les quatre petites filles*, written between November 24. 1947. and August 13. 1948: *Picasso Ecrits*. op. cit.. p. 297.

32 Rosenblum. *The Romantic Child*. op. cit.. p. 29.

33 Raymond Cogniat. "Picasso: Figures au pluriel." *International Art Book* (Lausanne. 1959). p. 36.

34 Françoise Gilot. *Vivre avec Picasso* (Paris. 1965). p. 240.

35 *Picasso Ecrits*. op. cit.. p. 328.

36 Gertrude Stein. *Picasso* (London. 1938). pp. 14-15.

37 Picasso. *Poèmes et lithographies*. February 11 – September 16. 1941 [first ed. with lithographs from the year 1949] (Paris. 1954): repr. in *Picasso Ecrits*. op. cit.. pp. 287-88.

38 Daniel-Henry Kahnweiler. in *Aujourd'hui* (Paris. September 1955). p. 13.

Works listed by date

Boy Scratching Himself 1896

Pencil and charcoal on paper
23 ⁷/₈ x 13 ³/₄ in. (60.7 x 35 cm)
Museu Picasso, Barcelona
p.8

First Communion 1896
La primera comunión

Oil on canvas
65 ³/₈ x 46 ¹/₂ in. (166 x 118 cm)
Museu Picasso, Barcelona
p.20

Child with Dove 1901
Enfant au pigeon

Oil on canvas
28 ³/₄ x 21 ¹/₄ in. (73 x 54 cm)
National Gallery, London
p.13

Child Seated in a Chair 1901
Enfant assis dans un fauteuil

Oil on canvas
25 ⁵/₈ x 21 ⁵/₈ in. (65 x 55 cm)
Barnes Foundation, Merion
p.14

Le gourmand 1901

Oil on canvas
36 ¹/₂ x 26 ⁷/₈ in. (92.8 x 68.3 cm)
National Gallery of Art, Washington
The Chester Dale Collection
p.15

Café in Montmartre –
the Flower Seller 1901
*Brasserie à Montmartre,
la marchande de fleurs*

Oil on canvas
17 ¹/₂ x 21 in. (44.5 x 53.5 cm)
Sammlung Ludwig, Cologne
p.22

Mother and Child
by the Sea 1902
Mère et enfant au bord de la mer

Oil on canvas
32 ⁵/₈ x 23 ⁵/₈ in. (83 x 60 cm)
Sammlung Beyeler, Basel
p.17

The Mistletoe Seller 1902-3
Le marchand de gui

Gouache
21 ⁵/₈ x 15 in. (55 x 38 cm)
Private collection
p.18

La soupe 1903

Oil on canvas
14 ⁵/₈ x 17 ³/₄ in. (37 x 45 cm)
The J. H. Grang Collection, Toronto
p.16

The Soler Family 1903
*Le déjeuner sur l'herbe de la
famille Soler*

Oil on canvas
59 x 78 ³/₄ in. (150 x 200 cm)
Musée d'Art Moderne de la Ville, Liège
p.25

Les misérables 1903

Ink with blue wash
14 ³/₄ x 10 ¹/₂ in. (37.5 x 26.7 cm)
The Whitworth Art Gallery,
University of Manchester
p.27

The Blind Man and the Girl 1904
L'aveugle et le jeune fille

Ink and watercolor on paper
18 ¹/₈ x 12 ¹/₄ in. (46 x 31 cm)
Max G. Bollag, Zurich
p.26

Boy with a Dog 1905
Garçon au chien

Gouache on cardboard
22 ¹/₂ x 16 ¹/₈ in. (57 x 41 cm)
Hermitage Museum, St. Petersburg
p.12

Harlequin's Family 1905
Famille d'arlequin

Gouache and ink on cardboard
11 ⁵/₈ x 8 ¹/₄ in. (29.5 x 21 cm)
Portland Museum of Art, Portland
The John Whitney Payson Collection
p.28

Actor and Child 1905
Comédien et enfant

Gouache and pastel
27 ³/₄ x 20 ¹/₂ in (70.5 x 52 cm)
The National Museum of Art, Osaka
p.29

Family of Acrobats
with Monkey 1905
Famille d'acrobates avec singe

Gouache, watercolor, chalk and
ink on cardboard
41 x 29 ¹/₂ in. (104 x 75 cm)
Konstmuseum Göteborg
p.30

Artistes 1905

Gouache on canvas
35 ¹/₂ x 28 in. (90 x 71 cm)
Staatsgalerie Stuttgart
p.31

The Family of Saltimbanques 1905
*La famille de saltimbanques
(Les bateleurs)*

Oil on canvas
83 ³/₄ x 90 ³/₈ in. (212.8 x 229.6 cm)
National Gallery of Art, Washington,
The Chester Dale Collection
p.32

Family of Saltimbanques 1905
Famille de saltimbanques

Ink and watercolor on paper
9 ⁵/₈ x 12 in. (24.3 x 30.5 cm)
The Baltimore Museum of Art,
The Cone Collection
p.34

Acrobat with Ball 1905
Fillette acrobate à la boule

Oil on canvas
57 ⁷/₈ x 37 ³/₈ in (147 x 95 cm)
Puschkin Museum, Moscow
p.35

Little Girl Balancing
on Horseback 1905
Fillette debout sur un cheval

Ink drawing on paper
9 ¹/₄ x 12 in. (23.5 x 30.5 cm)
The Baltimore Museum of Art,
The Cone Collection
p.40

The Adolescents 1905
Les adolescents

Oil on canvas
59 5/8 x 36 7/8 in. (51.5 x 93.7 cm)
National Gallery of Art. Washington
p.42

La coiffure 1906

Oil on canvas
68 7/8 x 39 1/4 in. (175 x 99.7 cm)
The Metropolitan Museum of Art.
New York
p.36

Man. Woman and Child 1906
Homme, femme et enfant

Oil on canvas
45 1/4 x 35 in. (115 x 89 cm)
Öffentliche Kunstsammlung Basel.
Kunstmuseum
p.37

The Two Brothers 1906
Les deux frères

Gouache on cardboard
31 1/2 x 23 1/4 in. (80 x 59 cm)
Musée Picasso. Paris
p.38

The Two Brothers 1906
Les deux frères

Oil on canvas
55 7/8 x 38 1/4 in. (142 x 97 cm)
Öffentliche Kunstsammlung Basel.
Kunstmuseum
p.41

Mother and Child 1907
Mère et enfant

Oil on canvas
31 7/8 x 23 5/8 in. (81 x 60 cm)
Musée Picasso. Paris
p.45

Little Girl with Doll 1917
Jeune fille à la poupée

Pencil on paper
11 3/4 x 9 5/8 in. (30 x 24.5 cm)
p.46

Mademoiselle Rosenberg 1918

Pencil on paper
12 5/8 x 8 7/8 in. (32 x 22.5 cm)
p.9

Girl with a Hoop 1919
Fillette au cerceau

Oil on canvas
55 7/8 x 31 1/8 in. (142 x 79 cm)
Musée national d'art moderne.
Centre Georges Pompidou. Paris
p.47

Les premiers communiants 1919

Oil on canvas
39 3/8 x 31 7/8 in. (100 x 81 cm)
Musée Picasso. Paris
p.48

Les communiants 1919

Oil on canvas
13 3/4 x 9 1/2 in. (35 x 24 cm)
p.49

Motherhood 1921
Maternité

Oil on canvas
p.53

Mother and Child 1921
Maternité

Oil on canvas
60 5/8 x 40 7/8 in. (154 x 104 cm)
Bayerische Staatsgemäldesammlungen.
Munich
p.54

Woman and Child
at the Seaside 1921
Femme et enfant au bord de la mer

Oil on canvas
56 3/8 x 63 3/4 in. (143 x 162 cm)
The Art Institute of Chicago
p.55

Portrait of a Child
in Pierrot Costume 1922
*Portrait d'un enfant en costume
de pierrot*

Gouache and watercolor
4 5/8 x 4 1/2 in. (11.7 x 11.5 cm)
Musée Picasso. Paris
p.51

Family at the Seaside 1922
Famille au bord de la mer

Oil on wood
6 7/8 x 8 in. (17.6 x 20.2 cm)
Musée Picasso. Paris
p.52

Mother and Child 1922
Mère et enfant

Oil on canvas
39 3/8 x 31 7/8 in. (100 x 81 cm)
The Baltimore Museum of Art.
The Cone Collection
p.60

Head of a Boy 1923
Tête de jeune homme

Grease crayon on paper
24 1/2 x 18 5/8 in. (62.1 x 47.4 cm)
The Brooklyn Museum, Brooklyn
p.50

Paolo, the Artist's Son,
Aged Two 1923
Paul, fils de l'artiste, à deux ans

Oil on canvas
39 3/8 x 31 7/8 in. (100 x 81 cm)
Collection Bernard Picasso. Paris
p.58

Paolo Drawing 1923
Paul dessinant

Oil on canvas
51 1/4 x 38 3/8 in. (130 x 97.5 cm)
Musée Picasso. Paris
p.59

Paolo as Harlequin 1924
Paul en harlequin

Oil on canvas
51 1/4 x 38 3/8 in. (130 x 97.5 cm)
Musée Picasso. Paris
p.57

Paolo as Pierrot
(the Artist's Son) 1925
Paul en Pierrot (Le fils d'artiste)

Oil on canvas
51 1/4 x 38 1/4 in. (130 x 97 cm)
Musée Picasso. Paris
p.56

Paolo, the Artist's Son,
as Pierrot 1929
*Portrait de Paul, le fils de l'artiste,
en Pierrot*

Oil on canvas
51 1/4 x 38 1/4 in. (130 x 97 cm)
p.63

Blind Minotaur, Led by a
Young Girl 1934
*Minotaure aveugle, conduit par
une petite fille*

Charcoal on paper
20 x 13 ¾ in. (51 x 35 cm)
Private collection. Hamburg
p. 68

Blind Minotaur, Led by a
Little Girl 1934
*Minotaure aveugle, guidé par une
fillette*

Ink, oils and mixed media
13 ¾ x 20 in. (35 x 51 cm)
p. 69

La Minotauromachie 1935

Etching
19 ½ x 27 ¼ in. (49.6 x 69.3 cm)
p. 72

Man with Mask, Wife, and Child
in Its Cradle 1936
*Homme masqué, femme et enfant
dans son berceau*

Ink drawing with wash
19 ¾ x 26 in. (50.3 x 66 cm)
Musée Picasso. Paris
p. 70

Man with Mask, Wife and Child
on Her Arm 1936
*Homme masqué, femme avec enfant
sur le bras*

Ink drawing with wash
26 x 19 ⅝ in. (66 x 50 cm)
Musée Picasso. Paris
p. 71

Study for *Guernica* 1937
Étude pour Guernica

Oil on canvas
21 ⅝ x 18 ⅛ in. (55 x 46 cm)
p. 65

Mother with Dead Child
(Study for *Guernica*) 1937
Étude pour Guernica

Pencil and colored chalks on paper
18 x 9 ⅝ in. (45.7 x 24.4 cm)
Museo Nacional del Prado
Cason del Buen Retiro. Madrid
p. 67

Study for *Guernica* 1937
Étude pour Guernica

Ink on paper
9 ½ x 17 ¾ in. (24 x 45 cm)
p. 74

The Butterfly Catcher 1938
Le chasseur de papillons

Oil on canvas
p. 77

The Artist's Daughter
with a Boat 1938
La fille de l'artiste avec un bateau

Oil on canvas
24 x 18 ⅛ in. (61 x 46 cm)
Collection A. R.
p. 80

Maya with a Doll 1938
*La fille de l'artiste avec sur les bras
une poupée coiffée d'un béret de
marin*

Oil on canvas
28 ¾ x 23 ⅝ in. (73 x 60 cm)
Musée Picasso. Paris
p. 81

Woman, Cat on the Chair, and Child
under the Chair 1938
*Femme, chat sur la chaise et enfant
sous la chaise*

Pen and ink
17 ½ x 26 ¾ in. (44.3 x 68 cm)
Musée Picasso. Paris
p. 82

Child with Pacifier
under a Chair 1938
Enfant à la sucette sous la chaise

Oil on canvas
24 x 18 ⅛ in. (61 x 46 cm)
p. 83

Child in a Chair 1939
Enfant dans une chaise

Oil on canvas
21 ⅝ x 15 in. (55 x 38 cm)
p. 79

Seated Child 1939
Enfant assis

Oil on canvas
28 ¾ x 23 ⅝ in. (73 x 60 cm)
Private collection
p. 84

Boy with Lobster 1941
Jeune garçon à la langouste

Oil on canvas
51 ¼ x 38 ⅜ in. (130 x 97.3 cm)
Musée Picasso. Paris
p. 85

The Artist's Daughter 1942
La fille de l'artiste

Pencil on paper
13 ¾ x 8 ¼ in. (35 x 21 cm)
p. 11

The Artist's Daughter 1943
La fille de l'artiste

Pencil on paper
14 ⅝ x 12 ¼ in. (37 x 31 cm)
p. 78

First Steps 1943
Mère et enfant

Oil on canvas
51 ¼ x 38 ¼ in. (130 x 97 cm)
Yale University Art Gallery.
New Haven. Connecticut
p. 86

Child with Doves 1943
L'enfant aux colombes

Oil on canvas
63 ¾ x 51 ¼ in. (162 x 130 cm)
Musée Picasso. Paris
p. 87

Motherhood
(Vert-Galant Park) 1944
Maternité (Vert-Galant Parc)

Ink, watercolor and gouache on paper
12 x 16 in. (30.5 x 40.7 cm)
p. 91

The Charnel House 1945
Le charnier

Oil and charcoal on canvas
78 ⅝ x 98 ½ in. (199.8 x 250 cm)
The Museum of Modern Art. New York
p. 88

Claude, Aged Two, in His
Little Car 1949
*Claude à deux ans dans sa petite
voiture*

Oil on canvas
51 ¼ x 38 ¼ in. (130 x 97 cm)
p. 90

Claude, Aged Two 1949
Claude à deux ans

Oil on canvas
51 1/4 x 38 in. (130 x 96.5 cm)
p.108

Claude 1950

Lithograph
11 3/4 x 20 1/2 in. (38 x 52 cm)
p.10

Woman Drawing with
Her Children 1950
*Femme dessinant auprès
de ses enfants*

Oil on wood
81 7/8 x 51 1/4 in. (208 x 130 cm)
p.99

Girl Skipping Rope 1950
Petite fille sautant à la corde

Bronze, after an assemblage
59 7/8 x 24 3/8 x 25 5/8 in.
(152 x 62 x 65 cm)
Musée Picasso, Paris
p.100

Woman with Baby Carriage 1950
Femme à la voiture d'enfant

Bronze, after an assemblage
79 7/8 x 57 x 23 5/8 in.
(203 x 145 x 60 cm)
Musée Picasso, Paris
p.101

Paloma with a Toy Fish 1950
Paloma, fond rouge

Oil and ripolin on plywood
51 1/4 x 38 1/4 in. (130 x 97 cm)
p.109

Massacre in Korea 1951
Massacre en Corée

Oil on plywood
43 1/4 x 78 3/4 in. (110 x 200 cm)
Musée Picasso, Paris
p.75

Françoise Gilot with Her Daughter
Paloma and Son Claude 1951
*Françoise Gilot avec sa fille Paloma
et son fils Claude*

Ripolin on plywood
44 7/8 x 57 1/2 in. (114 x 146 cm)
p.102

Paloma and Her Doll on
Black Background 1952
Paloma et sa poupée, fond noir

Lithograph
28 3/4 x 21 5/8 in. (73 x 55 cm)
Sammlung Ludwig, Cologne
p.93

Baboon and Young 1952
La guenon et son petit

Bronze, after an assemblage
21 5/8 x 13 3/8 x 24 3/4 in.
(55 x 34 x 63 cm)
Musée Picasso, Paris
p.97

Paloma Asleep 1952
Paloma endormie

Oil on plywood
45 5/8 x 62 1/4 in. (116 x 158 cm)
Private collection, New York
p.106

Drawing done jointly by Picasso,
Paloma and Claude 1953

Pencil and colored pencil on paper
26 x 19 1/2 in. (66 x 49.5 cm)
p.94

The Children's Mealtime 1953
Le repas des enfants

Oil on plywood
38 5/8 x 19 1/2 in. (98 x 130 cm)
p.103

Child Playing with a Toy Truck 1953
Enfant jouant avec un camion

Oil on canvas
51 1/4 x 38 in. (130 x 96.5 cm)
Musée Picasso, Paris
p.104

In Front of the Garden 1953
Devant le jardin

Oil on canvas
59 1/4 x 38 3/4 in. (150.5 x 98.5 cm)
Private collection
p.105

Paloma's dolls ca. 1953

Wood
Paloma Picasso Lopez Collection
p.98

The Piano 1957
Le piano

Oil on canvas
51 1/4 x 37 3/4 in. (130 x 96 cm)
Museu Picasso, Barcelona
p.113

Las Meninas. The Infanta
Margarita María 1957
*Les Ménines. Infant
Margarita María*

Oil on canvas
16 1/8 x 12 3/4 in. (41 x 32.5 cm)
Museu Picasso, Barcelona
p.114

Las Meninas. Dona Isabel de
Velasco, the Dwarf, the Child,
and the Dog. No. 42 1957
*Les Ménines. Dona Isabel
de Velasco, le nain, l'enfant et
le chien. No 42*

Oil on canvas
51 1/4 x 37 3/4 in. (130 x 96 cm)
p.115

A page from the notebook
Dibujos y escritos

(p.IX, January 9, 1959)
p.110

Les déjeuners 1961

Chalk on paper
13 x 19 3/4 in. (33 x 50 cm)
p.92

Bathers 1961
Baigneuses

Chalk on paper
13 x 19 3/4 in. (33 x 50 cm)
p.92

Les déjeuners 1961

Chalk on paper
9 7/8 x 13 3/4 in. (25 x 35 cm)
p.92

Les déjeuners 1961

Chalk on Japan paper
9 7/8 x 13 3/4 in. (25 x 35 cm)
p.92

Woman and Child 1961
Femme à l'enfant

Tin sheet, folded and painted
50 ³/₄ x 21 ⁵/₈ in. (129 x 55 cm)
p. 96

The Rape of the
Sabine Women 1963
L'enlèvement des Sabines

Oil on canvas
76 ³/₄ x 51 ¹/₄ in. (195 x 130 cm)
Museum of Fine Arts, Boston
p. 89

Musketeer with Amor 1969
Mousquetaire et Amour

Oil on canvas
76 ³/₈ x 51 ¹/₄ in. (194 x 130 cm)
Sammlung Ludwig, Cologne
p. 116

Rembrandt Figure
with Amor 1969
Personnage rembranesque et Amour

Oil on canvas
63 ³/₄ x 51 ¹/₄ in. (162 x 130 cm)
Picasso-Sammlung der Stadt Luzern,
Donation Rosengart
p. 117

The Painter and the Child 1969
Le peintre et l'enfant

Oil on canvas
51 ¹/₄ x 76 ³/₄ in. (130 x 195 cm)
Musée Picasso, Paris
p. 119

Man and Child with Bird 1969
Homme et enfant à l'oiseau

Oil on canvas
76 ³/₄ x 51 ¹/₄ in. (195 x 130 cm)
p. 120

Untitled 1971
Sans titre

Manière noire
12 ⁵/₈ x 16 ¹/₂ in. (32 x 42 cm)
p. 111

Musketeer and Child 1972
Mousquetaire et enfant

Oil on canvas
63 ³/₄ x 51 ¹/₄ in. (162 x 130 cm)
Musée Picasso, Paris
p. 118

Winged Horse, Led by a Child
Holding a Branch 1972
*Cheval ailé, mené d'un enfant
qui tient une branche*

Gouache and ink
12 ³/₈ x 17 ¹/₂ in. (31.5 x 44.5 cm)
Private collection
p. 121

Paolo, the Artist's Son 1923
Paul, fils de l'artiste

Oil on canvas
10 ⁵/₈ x 8 ⁵/₈ in. (27 x 22 cm)
Private collection
p. 128

PHOTOGRAPHS

Pablo, aged four
p. 7

Advertising photo from the
Grandval photographic studio 1914
p. 48

Paolo riding a donkey 1923
p. 62

Paolo dressed as a torero ca. 1930
Musée Picasso, Paris
p. 64

Picasso drawing with Paloma
and Claude 1953
p. 95

Picasso in a sedan chair,
with Paloma and Claude ca. 1955
Musée Picasso, Paris
p. 2

Toy cars: a Panhard
and a Renault
p. 97

Photograph Credits

Bayerische Staatsgemälde-
 sammlungen, Munich p. 54
By kind permission of the Galerie
 Beyeler, Basel p. 84
Photographie Giraudon, Vanves
 pp. 35, 115
Musée national d'art moderne, Centre
 Georges Pompidou, Paris p. 47
Musée Picasso, Paris jacket, pp. 2, 38,
 45, 48 (2), 52, 64, 81, 87, 104, 118-19

Museu Picasso, Barcelona p. 113
National Gallery of Art, Washington
 p. 42
Öffentliche Kunstsammlung Basel,
 Martin Bühler p. 37
Réunion des Musées Nationaux, Paris
 p. 57
Sotheby's, London pp. 79, 91, 94-95
Staatsgalerie Stuttgart p. 31

Paolo,
the Artist's Son
1923